A STUDIO PRESS BOOK

First published in the UK in 2022 by Studio Press,
an imprint of Bonnier Books UK,
4th Floor, Victoria House, Bloomsbury Square,
London WC1B 4DA
Owned by Bonnier Books, Sveavägen 56, Stockholm, Sweden

www.bonnierbooks.co.uk

3 5 7 9 10 8 6 4 2

ISBN 978-1-80078-340-9

Written by Rachael Taylor
Edited by Ellie Rose
Designed by Maddox Philpot and Krissy Omandap
Picture Research by Paul Ashman
Production by Emma Kidd

A CIP catalogue record for this book
is available from the British Library

Printed and bound in China

The publisher would like to thank the following for supplying photos for
this book: Alamy, Getty, iStock, Magnum and Shutterstock. Every effort
has been made to obtain permission to reproduce copyright material but
there may be cases where we have not been able to trace a copyright holder.
The publisher will be happy to correct any omissions in future printing.

Cartier

The Story Behind the Style

RACHAEL TAYLOR

Contents

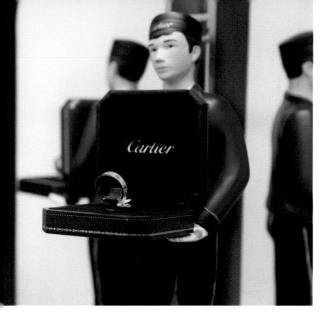

LEFT: A Cartier Love ring in the maison's signature red box is offered by a figurine of its iconic bellboys.

Welcome to the Maison

Cartier is the epitome of French luxury. The maison has captured the hearts of shoppers across the globe with its chic bellboys, plush boutiques and expertly crafted jewels and watches in signature red boxes. The brand's instantly recognisable designs – such as the iconic Love bracelet and Tank watch – have become must-haves for followers of luxury fashion; unspoken codes to communicate sartorial savvy. Stars, too, have fallen under the spell of Cartier. Its designs are regularly seen lighting up the face of an actress on the red carpet, or flashing just beneath the cuff of a tuxedo on a famous wrist.

Cartier very much feels like a contemporary brand, but it is one that has a long history, dating back to 19th-century Paris. It emerged as a brand of repute in an era when tsars, emperors and maharajas were the influencers of the day, and when a store on New York's Fifth Avenue could be bought for a string of pearls. Its origin story is one that is intertwined with the history of the family that named it. A tale, quite literally, of rags to riches.

It is also a story of pioneers and firsts. Driven by a desire to always create and never follow, the Cartiers would break ground that would not only set their own business on a new trajectory, but the entire watch and jewellery world. It spearheaded the use of platinum, helped shape the Art Deco jewellery movement and even created what can be considered the first commercial men's wristwatch.

As Cartier's global empire took shape, its innovation did not falter — nor did its loyal clientele, which has long

included royal families. This luxury shapeshifter has seemed to effortlessly move with the times, finding fresh relevance and ensuring its creations are just as desirable in the 21st century as when it took its first tentative steps in the 1840s.

ABOVE: A classic Cartier bag in the brand's signature red.

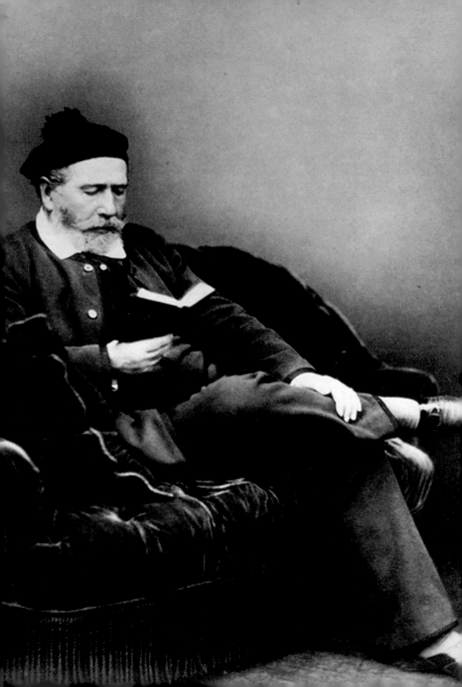

The Beginnings
of Cartier

The house of Cartier started with one man, Louis-François Cartier, but it would take a family to make it one of the most recognised and respected jewellers in history.

It was, in fact, Louis-François' father, Pierre Cartier, who set the dynasty in motion, although he could never have imagined the consequences of his actions at the time. Pierre had fought in the Napoleonic wars and spent time locked in the prison ships docked off the harbour at Portsmouth in Britain. When the war ended in 1815, Pierre returned to Paris, destitute and aimless. He would go on to find employment as a metalworker and have five children with his wife Elisabeth, a washerwoman.

The eldest of the children born into this working-class Parisian family was Louis-François, and when he was barely out of school, his father sent him to work as an apprentice in a jewellery workshop owned by Adolphe Picard on Rue Montorgueil in Paris. It was a tough education – days were long and gruelling and order was maintained with a whip – but he stayed and in 1847, at the age of 27, Louis-François bought the business from Picard, renaming it Cartier.

OPPOSITE: Cartier founder, Louis-François Cartier.

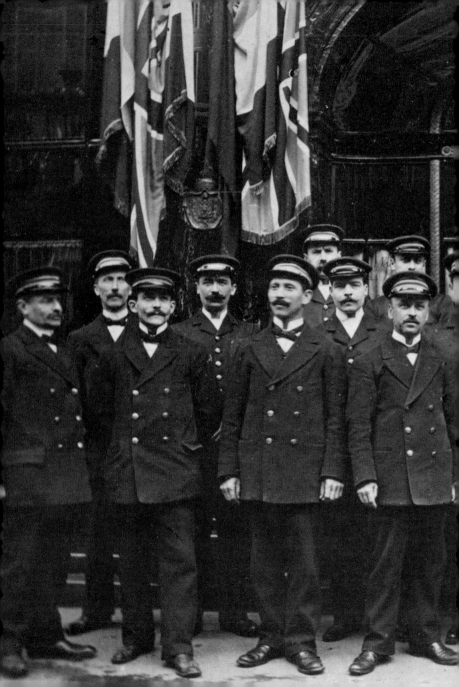

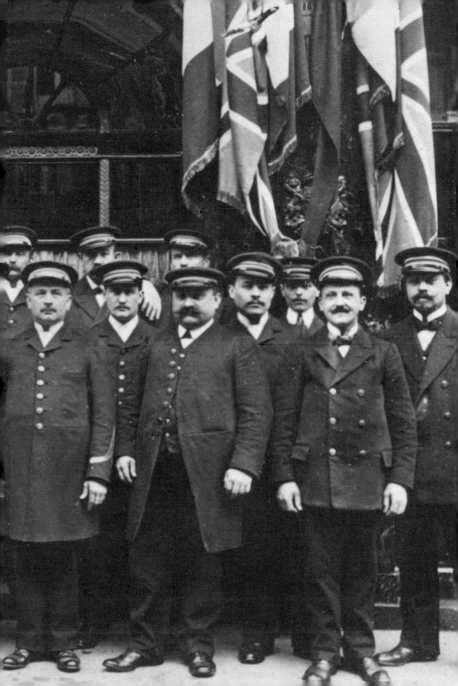

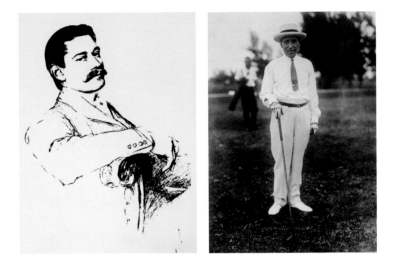

His makers mark – a symbol hallmarked into every piece of Cartier jewellery to authenticate it – was his initials, L C, separated with an ace of hearts playing card, perhaps as a nod to the financial gamble he was taking. Luckily, the risk paid off and the Cartier business thrived and expanded. In 1856, Princess Mathilde, a cousin of Emperor Napoleon III, purchased one of its jewels, and the Cartier name was suddenly whispered among Parisian high society, even reaching the international elite. Three years later, Louis-François bought Gillion, a Parisian jeweller better known than his own, and renamed his business Cartier Gillion.

Louis-François' son Alfred Cartier took over the family business in 1874, but it was the arrival of his own three sons – the highly ambitious Louis, Pierre and Jacques – that would really shake up the jeweller and initiate its ascendance to the global brand we know today. The brotherly revolution started with Louis, who joined the maison in 1898. A year later he spearheaded the renaming

PREVIOUS: Staff gather outside a Cartier boutique in Paris in 1918.

OPPOSITE LEFT: An illustration of Louis-François Cartier, c.1848.

OPPOSITE RIGHT: Pierre Cartier playing golf in Miami.

of the business, stripping away Gillion to once again be known simply as Cartier. At the same time, the business opened a boutique at 13 rue de la Paix, just a stone's throw from Place Vendôme, the heartland of luxury jewellery in Paris. This venture was funded by an enormous dowry levied through a strategic arranged marriage to Andrée-Caroline Worth, granddaughter of world-famous couturier Charles Frederick Worth.

Cartier garnered a reputation for innovation, and the trio of brothers would later live by a motto, 'Never copy, only create.' One of Louis' most successful experiments at the close of the 19th century was to use platinum in place of gold. This precious metal is now widely used by jewellers across the world, but at the time it was purely an industrial metal and thus revolutionary in the jewellery market. The white metal, which, unlike silver, does not tarnish, is highly malleable and allowed Cartier to create delicate, diamond-set jewels inspired by those owned by 18th-century French aristocrats; a stark contrast to the heavier, colourful, feminist Art Nouveau jewels popular at the time. A signature Cartier Garland style emerged, swirling across platinum tiaras, necklaces and earrings, that won over well-heeled women, including royals, in Europe and the United States.

Pierre Cartier, the second eldest of the brothers, would be an agitator in his own right, championing the global expansion of the brand's retail empire. He started by opening a Cartier boutique on New Burlington Street in London in 1902, where the brand showcased a new style of geometric, abstract jewels with unusual colour combinations that would lay the foundations for the Art Deco jewellery movement.

The first decade of the 20th century was an important time for Cartier. In 1904, the jeweller received its first royal certificate from King Edward VII of Britain, and soon started to supply many other royal courts including those of Russia, Spain and Siam (now Thailand). In the same year, Louis Cartier created what he believed to be the first ever men's wristwatch for aviator Alberto Santos-Dumont.

Pierre, meanwhile, embarked on a journey to Russia; one that would prove profitable in commissions from its high society, but also as a source of inspiration that would shape Cartier's jewellery designs for years to come.

In 1909, Pierre would focus his wanderlust on America, opening a Cartier boutique on New York's Fifth Avenue; the precursor to its famous flagship store further up the street, the purchase of which he would famously broker a decade later in exchange for a string of pearls. Back in London, his younger brother Jacques stepped in to take over its British branch. That same year, Cartier moved uptown to a prestigious Bond Street address, where it remains to this day.

As Cartier's man in Britain, and, as such, jeweller to King George V, Jacques joined members of the aristocracy on a trip to India for the Delhi Durbar in 1911. It was an event

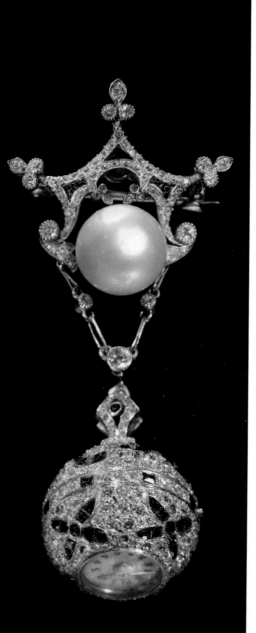

to commemorate the coronation of the King, with two weeks of festivities, during which King George V and Queen Mary would be proclaimed Emperor and Empress of India. This adventure to a new land would also prove to be a seminal trip for the house of Cartier. Jacques' sociable nature and love of travel would win ground-breaking commissions from India's rich, jewel-loving maharajas and inspire a whole new category of jewellery, pioneered by Cartier and much copied by other companies.

LEFT: Cartier platinum pendant watch set with diamonds, rubies and a pearl, c.1890–1910.

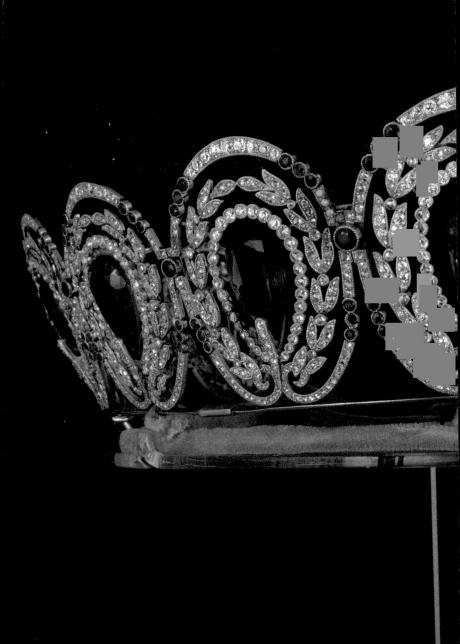

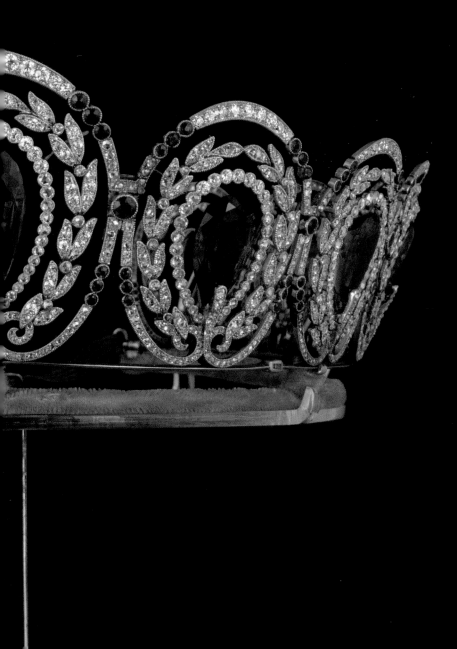

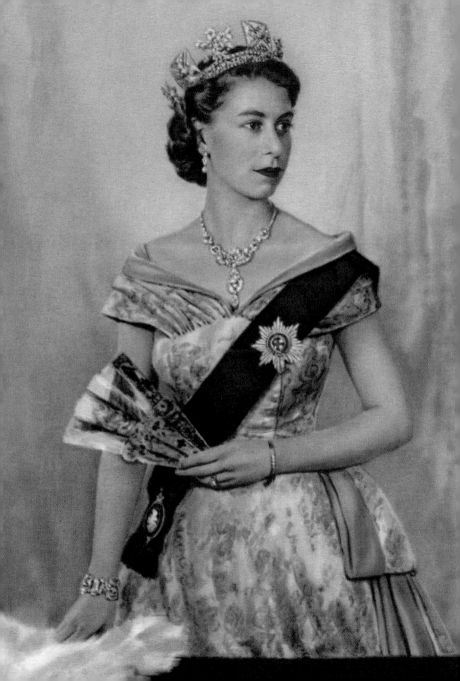

Royal Affiliations

A major coup for Cartier, and one that would win it respect worldwide, was its connection with the British royal family. The relationship started in 1904 with a royal warrant granted by King Edward VII appointing Cartier as his jeweller. Cartier's relationship with the royal family had actually begun two years earlier. Pierre Cartier had opened a boutique in London in 1902, coinciding with the coronation of King Edward VII, and had managed to catch his attention. The palace ordered 27 tiaras from Cartier for the coronation.

More commissions would follow; everything from grand diamond and ruby colliers to silver carriage clocks. Having achieved the British royal seal of approval, demand for Cartier soon came from other royal courts around the world, including Spain, Siam, Belgium and Russia.

Tiaras would prove to be an item that the British royal family continued to turn to Cartier for. The most famous of these is the Halo tiara, a platinum design embellished with graduated scrolls glittering with 739 round

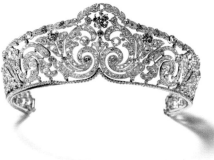

PREVIOUS: Amethyst and diamond diadem created by Louis Cartier.

OPPOSITE: A portrait of Her Majesty Queen Elizabeth II wearing the Cartier Nizam of Hyderabad necklace, c.1953.

ABOVE: Platinum and diamond tiara made for Queen Elisabeth of Belgium by Cartier in 1910.

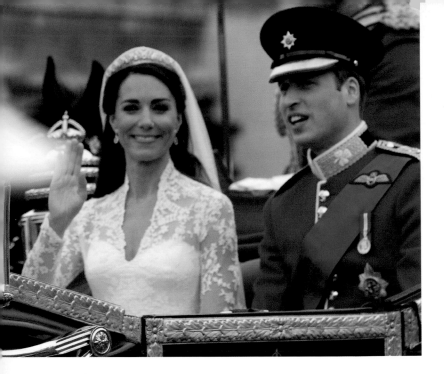

brilliant diamonds and 149 baguette-cut diamonds. It was commissioned by George VI as a gift for his wife, Queen Elizabeth, in 1936. It would later pass to their daughter Elizabeth II, who never wore the Halo tiara in public but did allow her sister Princess Margaret to do so. In 2011, the Cartier tiara had another moment in the spotlight when the Duchess of Cambridge wore it during her wedding to Prince William.

ABOVE: Kate Middleton, the Duchess of Cambridge, wearing the Cartier Halo tiara during her wedding to Prince William in 2011.

OPPOSITE: Queen Alexandra of Great Britain pictured wearing the diamond Collier Résille necklace with detachable emeralds and rubies that she commissioned from Cartier in 1904.

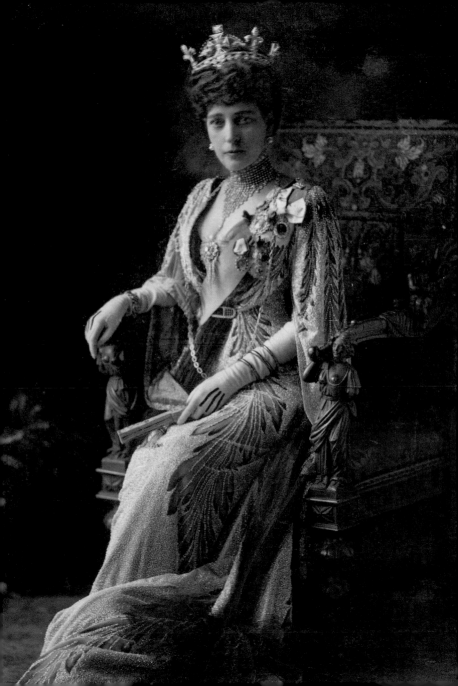

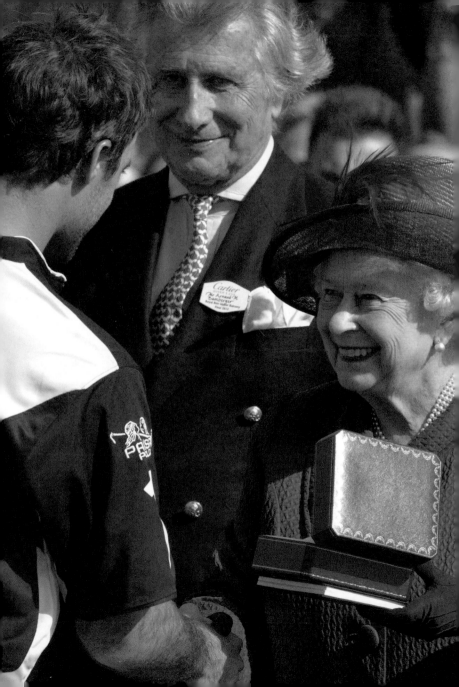

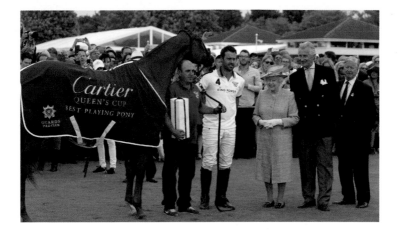

"Jeweller of kings and king of jewellers."
King Edward VII of Britain

The relationship between Cartier – which King Edward VII once famously proclaimed "jeweller of kings and king of jewellers" – and the British royal family continues to this day. As well as crafting its jewels, in 2012 Cartier was named the sponsor of one of the Queen's favourite days out, a polo match now known as the Cartier Queen's Cup.

OPPOSITE: Queen Elizabeth II presents the Cartier Queen's Cup to polo player Facundo Pieres in 2013.

ABOVE: Queen Elizabeth II presents the prize for Best Playing Pony at the Cartier Queen's Cup tournament in 2015.

New Ideas for a New Century

While Cartier flourished in the 19th century, it wasn't until the 20th century that it would really set a trajectory to become one of the most famous jewellery and watch houses in history. Much of this was thanks to the leadership of the Cartier brothers Louis, Pierre and Jacques.

The trio leaned into their passions to simultaneously take the brand into new directions and territories, making waves in the world of design and striking up influential international alliances. It is said that the brothers sat down with a map and sectioned off Europe, the Americas and Great Britain, assigning a region to each one of them to conquer.

It would also herald the arrival of Jeanne Toussaint, and with her one of Cartier's most famous motifs of all, the Panthère.

OPPOSITE: Cartier has often used leopards in its advertising campaigns, including real ones on occasion.

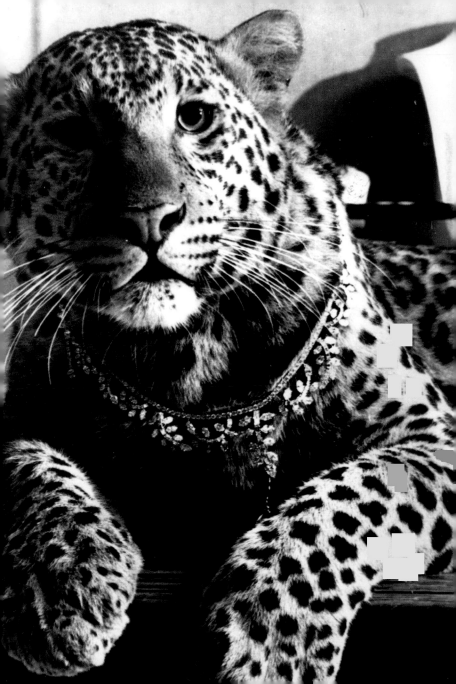

The First Men's Wristwatch

While Cartier cannot lay claim to inventing the wristwatch, it can perhaps be credited with designing the first men's watch and kickstarting an industry that is now worth billions of dollars.

Wristwatches became a popular accessory among 18th-century women as a way to transport the time. Ladies' fashions at the time did not provide pockets from which to hang a pocket watch, as men did. Swiss watchmaker Breguet claims to have made the first wristwatch in 1810 for Caroline Murat, the Queen of Naples, although historians will point to evidence that shows timepieces being made as early as the 1500s. It is said that Queen Elizabeth I of England received one from her suitor Robert Dudley.

In 1904, Alberto Santos-Dumont, a Brazilian living in Paris, was tussling with the challenge of flight. A year earlier, the Wright brothers had achieved this with the aid of a rail track to jettison their craft, but Santos-Dumont was focused on an unaided ascent (something he would achieve in 1906).

To help his calculations, Santos-Dumont needed

a timepiece, but with his hands busy at the controls of his aeroplane, he could not easily pull out his pocket watch.

His friend Louis Cartier believed he had a solution: why not put the watch on a strap to be worn round the wrist? To differentiate it from the decorative ladies' watches, Cartier adopted an industrial style for the watch, making a feature of the screws watchmakers usually tried to hide. He also fixed it to a leather strap – a material that was unheard of at the time in watchmaking.

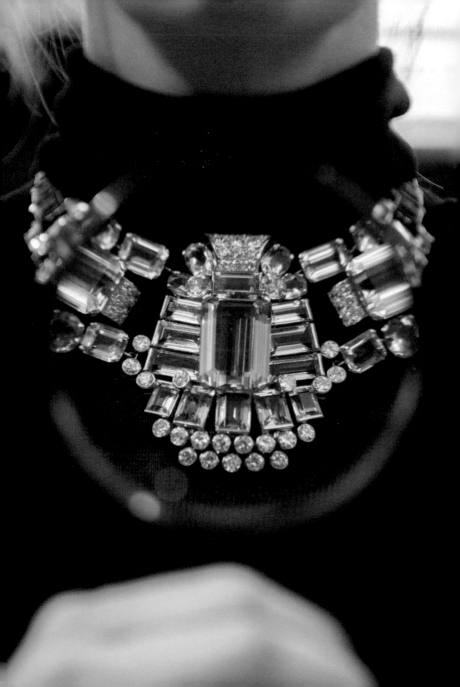

This problem-solving innovation would prove to be the beginning of a new chapter both for Cartier and for all watchmakers, as men started to seek out this modern and convenient method of keeping the time. The design would also form the basis of one of Cartier's most popular timepieces, named Santos in honour of the aviator who inspired it.

At the Heart of Art Deco

The mood in jewellery shifted as World War I came to a close in 1918. The styles so popular before the Great War – elaborate Edwardian jewels and Belle Epoque excess – no longer fitted the sentiment of the people. Instead, collectors sought something fresh that would better chime with changing fashions, and so began the era of Art Deco jewels.

Art Deco jewellery could be defined, first and foremost, by colour and contrast. The swirling Garland style that had won Cartier status at the end of the 19th century was replaced with geometric, abstract shapes and bold colour combinations. These jewels favoured semi-precious gems and hardstones over diamonds, and small diamonds in pavé settings over large cuts. Jewels were streamlined to suit modern women's clothing, which had become less fussy and often had an androgynous edge, as pioneered by fellow Parisian Coco Chanel.

Cartier is credited as being one of the leading pioneers of this movement, claiming to have started its transition

OPPOSITE: An Art Deco aquamarine and diamond necklace by Cartier, c.1940, auctioned at Bonhams in 2019.

to this modern style as early as 1900. At the peak of the craze in 1925, Cartier exhibited 150 Art Deco jewels at the Exposition Internationale des Arts Décoratifs et Industriels Modernes in Paris that celebrated the style, which had swept through jewels, architecture, art and design.

It was Louis Cartier who pushed Cartier's Art Deco style forward, aided by head designer Charles Jacqueau who joined the maison in 1909. As well as the stark lines inspired by Cubism, Futurism and Bauhaus that defined jewels of this era, Art Deco had a more decorative side influenced by Asian artworks.

The Cartiers' love for travel helped set the brand's designs apart from other jewellers. Louis Cartier is said to have amassed an enormous personal collection of Chinese porcelain and objets d'art, while Jacques Cartier's travels to India furnished him with much inspiration, as well as the carved gems required to create one of Cartier's most enduring Art Deco jewellery collections – the highly collectable Tutti Frutti.

LEFT: A 1937 Cartier Art Deco platinum and diamond ring with a movement made by Jaeger-LeCoultre.

TOP LEFT: A 1927
Cartier platinum
Art Deco brooch
with carved
jadeite, diamonds,
enamel, emeralds,
sapphires and
rock crystal.

BOTTOM LEFT:
A 1927 Cartier Art
Deco platinum
and diamond
bracelet set with a
46.07ct Burmese
sapphire.

RIGHT: A 1914
Cartier diamond
and onyx Art
Deco necklace
once owned by
Armenian art
collector Calouste
Gulbenkian.

Inspiration from India

Cartier's relationship with India, and its rich, jewel-loving maharajas, was one that would propel it creatively and also prop it up financially. It would also lead to a brand-new style of jewellery that added colour and drama to the clean lines of the Art Deco movement. This important chapter of Cartier's history began in 1911 with a trip to India for the Delhi Durbar, a celebration to anoint England's King George V and Queen Mary as Emperor and Empress of India. As royal jeweller, Jacques Cartier travelled with the royal family to tend to their jewellery needs.

A savvy businessman, Jacques also planned to use the trip to drum up some business. There was, however, a flaw in his strategy. His suitcases were packed with elegant Belle Epoque jewels that he hoped to sell to India's society women. He wasn't aware that the real market in India was dominated by men, who liked to buy lavish, colourful jewels for themselves. On that first trip, Jacques sold some gold pocket watches and bought some gemstones from India's famous lapidarists. He also made it his mission to ingratiate himself with the royal families of India. He succeeded in receiving invitations to the palaces of important houses including Patiala, Nawanagar, Kapurthala and Baroda.

Initially, Jacques made the trips by donkey and later in his Rolls-Royce, which he had shipped over for his tours. The terrain in India was tough. On one occasion, in order to cross the Himalayas to meet the King of Nepal, he had to have his beloved car taken apart and carried in pieces over the mountains, to be reassembled on the other side. Jacques' adventures, on which he was often accompanied by his wife Nelly Cartier, would prove fruitful... and not just for his memoirs. The maharajas embraced Cartier's jewellery style,

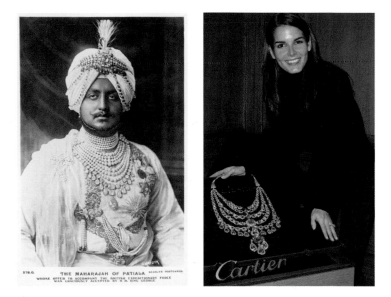

which was different from traditional Indian jewellery, and enjoyed the prestige of engaging a European jeweller. Many major commissions would follow, including the Maharaja of Patiala who trusted Cartier to reset his crown jewels. Between 1925 and 1928, Cartier's Parisian workshop would use the jewels to create a spectacular bib necklace set with almost 1,000 carats of diamonds, including a 234ct yellow diamond mined by De Beers.

ABOVE LEFT: A portrait of the Maharaja of Patiala in some of his famous jewels.

ABOVE RIGHT: Actress Angie Harmon shows off the necklace Cartier made for the Maharaja of Patiala in 1928.

With great wealth and palaces full of incredible gems, the maharajas and their families would become important clients for Cartier. They became even more important when World War I, the Russian Revolution and, later, the Great Depression cut the spending power of Cartier's best clients in Europe, Russia and the US.

Working with Indian royalty and travelling around the country also inspired Jacques creatively. He would sketch the architecture he discovered and marvel at how different the light was to that of Europe. He would buy gemstones from India's many fruitful mines and fixate on the Mughal jewellery style with its floral flourishes, strings of cabochon beads and carved gemstones.

The Indian influence on Cartier began to diverge. There were the Indian jewels reimagined in a Western style for the maharajas, many of whom would travel to Paris in search of jewellers to work with. Then there were the Western jewels

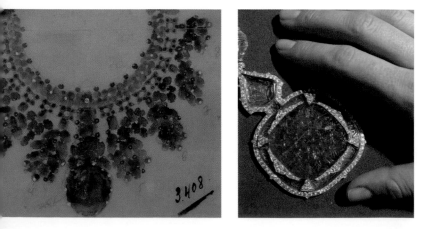

reimagined in an Indian style for its clients in Europe and the US.

Emeralds and pearls became more prominent in Cartier's designs because of the influence of India, as well as tassels of gemstone beads, smooth cabochon gem cuts without facets, and gemstones decorated with artistic carvings of the type used in its Tutti Frutti designs (a name they acquired long after this period). Brooches designed for Western women would take their form from jewels used to secure turbans in India, while silhouettes of other jewels took inspiration from Indian architecture and nature.

India would also play a role in securing Cartier's position as creator of the most expensive jewel owned by the British royal family. As a wedding gift to Queen Elizabeth II in 1947, Asaf Jah VII, the ruler – or Nizam – of Hyderabad, left instructions with Cartier to allow the bride to select anything she wanted. The Queen chose a tiara and also a diamond and platinum necklace now known as the Nizam of Hyderabad necklace (see page 18). The latter is believed to be worth tens of millions of pounds, and has since also been worn by the Duchess of Cambridge.

OPPOSITE LEFT: A 1938 painting of a Cartier Tutti Frutti necklace, exhibited at The Denver Art Museum in 2014.

OPPOSITE RIGHT: A 1912 carved emerald, rock crystal and diamond Cartier necklace once owned by novelist Vita Sackville-West.

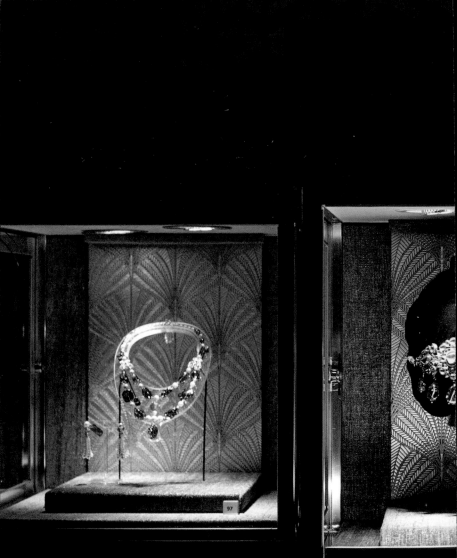

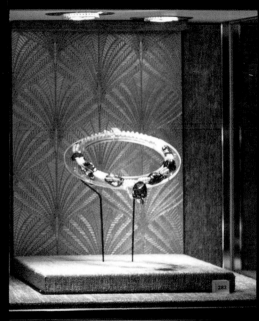

282

Jeanne Toussaint

Jeanne Toussaint was born in Belgium in 1887, the daughter of lace makers. Growing up in a home surrounded by luxury handcrafting would serve her well when, in 1920, she became Cartier's creative director.

Toussaint lived a bohemian lifestyle that would lead to many fascinating experiences and famous acquaintances, including fashion designer Coco Chanel and illustrator George Barbier. Running away from home as a teenager, Toussaint took up with a French count, Pierre de Quisonas. The romance did not last, due to concerns from his family, but the encounter did lead her to Paris, where she would meet her next ill-fated lover, Louis Cartier.

Cartier was besotted with Toussaint, who was nicknamed Panther or Panpan for her love of the animals and, somewhat paradoxically, her signature full-length fur coat made of panther fur. Their romance would only last for two years – again, family pressures worked against the self-made Toussaint – but Louis saw in her more than just a lover, and asked her to join Cartier as a handbag designer.

PREVIOUS:
Cartier jewellery on display at Maharajas & Mughal Magnificence: A Collection of Extraordinary Treasures auction hosted by Christie's in 2019.

OPPOSITE:
A portrait of Cartier creative director Jeanne Toussaint, taken in 1946 by photographer Henri Cartier-Bresson.

Her remit would later widen, and she would eventually become the jeweller's creative director, overseeing not just leather goods but jewels and watches, too. It was unheard of at that time for a woman to be appointed to such a role, marking Cartier out as a progressive employer. Toussaint would repay this loyalty, staying with Cartier until the 1970s.

During this time, she created many collections for the jeweller and helped it secure a celebrity clientele who were entranced by her joie de vivre. But none of her designs would prove as iconic as Panthère. Though the panther was already a motif used by Cartier before her arrival, Toussaint elevated it and obsessively returned to it, transforming it into the symbol of the house.

As proof of her legacy, a diamond and onyx panther bracelet designed by Toussaint for Wallis Simpson, Duchess of Windsor, sold in 2010 for £4.5 million. At the time, it broke new records for the most expensive bracelet and the most expensive piece of Cartier jewellery ever sold at auction.

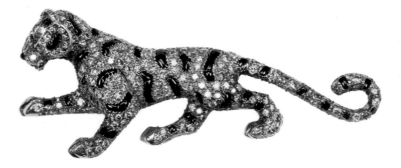

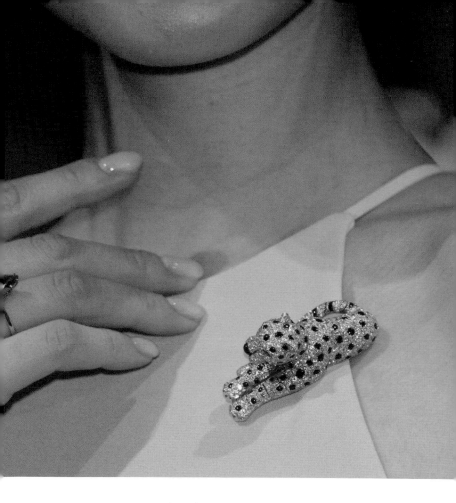

OPPOSITE:
An 18ct gold, onyx and gemstone
Cartier Panthère brooch.

ABOVE:
An onyx and diamond Cartier
Panthère brooch sold at Sotheby's
in 2017 for HK$2.5 million.

A Watchmaking Pioneer

Cartier kickstarted a watch revolution at the dawn of the 20th century with the creation of a men's wristwatch for Brazilian pilot Alberto Santos-Dumont. It would keep up its early momentum with a steady release of landmark creations and become a major player in luxury watches.

With a focus on aesthetics over horological complications, Cartier became known for timepieces that were a little different from the norm. It offered up experimental case shapes that appealed to both men and women, winning it famous fans throughout the 20th and 21st centuries, from Andy Warhol to Michelle Obama.

The opening of La Chaux-de-Fonds in the Swiss Alps would prove to be a major turning point, accelerating Cartier's watchmaking abilities.

OPPOSITE: Cartier Drive de Cartier chronograph, c.2020.

Watchmaking History

Cartier jettisoned itself into the horological history books by creating a men's wristwatch in 1904, but it started making transportable timekeepers long before this. From its very beginning, the jeweller sold chatelaine watches, miniature dials that hung from decorative brooches to be pinned onto clothing, and also pocket watches.

Pocket watches were a particular Cartier speciality, selling well through to the first half of the 20th century. These ranged from minimalist dials in gold or platinum cases to elaborate pocket watches embellished with enamel, diamonds, carved hardstones and raised monograms. It also created bejewelled travel clocks.

A distinctive style of pocket watch manufactured by Cartier in the early 20th century, alongside other makers including Patek Philippe, Piaget, Rolex and Audemars Piguet, was its coin pocket watches with covers made from real coins.

LEFT:
A 1997 advert for a Cartier Tank Française watch.

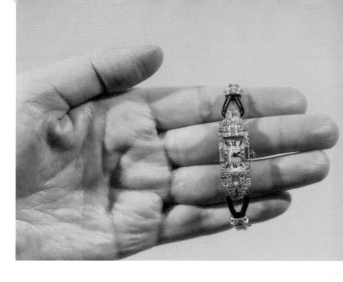

Pierre Cartier gifted one to his friend, the US President
Franklin D Roosevelt, in 1939, just months after France
had declared war on Germany. It was a Christmas gift, but
also a subtle diplomatic nudge for Roosevelt to take up
arms in World War II. In the accompanying note, Pierre
wrote, "Your Royal Visitors of last summer [King George
VI of Britain] foresaw the present war and came to visit The
Leader of the Democracies, through whose efforts only a
lasting peace will be established. The watch in the coin will
mark for you, The President, not only the hour of The Allies
victory, but the one of your Triumphs as The Peace Maker."

In 1943, two years after Roosevelt did indeed commit
US troops to the war effort, Cartier sent the president
another Christmas gift. This time it was a clock titled – in
hope – the Victory Clock. The clock was crafted in silver,
onyx and nephrite, and showed multiple time zones with the
main time set to Washington DC and sub dials synchronised
to London/Paris, San Francisco, Tokyo and Berlin. It later
sold for $1.6 million at auction house Sotheby's in 2007 to
an American collector.

One of Cartier's most iconic watches came about as a result of the previous world war. Louis Cartier fought on the Western Front in World War I and had been intrigued by the large armoured tanks that rolled through the battlefields. On his return to Paris, he sketched out a watch with a rectangular face and elongated lugs with bars – known as *brancards*, which is the French word for stretcher, another regular sight at the Front – to hold the leather strap. He called it the Tank, and it was first produced in 1918.

In the creation of the Tank, and indeed its predecessors the Tonneau in 1906 and Tortue in 1912, Louis Cartier had a collaborator. Edmond Jaeger, a French watchmaker, whose name lives on in the luxury watch brand Jaeger-LeCoultre, specialised in creating ultra-thin watch movements. Impressed by his work, Cartier entered into an exclusive deal with Jaeger and his business partner Jacques-David LeCoultre that would see them produce movements exclusively for Cartier between 1907 and 1921. Jaeger died the year after this exclusive contract was fulfilled, but Cartier would continue to work with Jaeger-LeCoultre long afterwards.

Cartier would go on to produce many watchmaking icons: the Salvador Dalì-esque Crash with its distorted case; the sleek dress watch Panthère; Pasha, inspired by a 1933 commission from the Pasha of Marrakech; and the Ballon Bleu with its signature domed crystal glass. Each further solidified Cartier's place as one of the most prolific and desired watchmakers in the world.

OPPOSITE TOP LEFT: An example of the Cartier Roadster, which was first released in 2001 and discontinued a decade later.

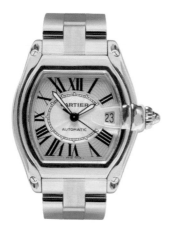

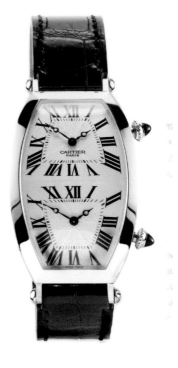

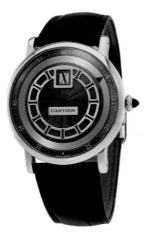

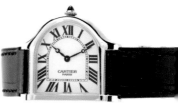

TOP RIGHT:
A Cartier Tonneau
XL which displays
two time zones.

BOTTOM LEFT:
Cartier Rotonde de
Cartier Jumping
Hours watch in
rose gold.

BOTTOM RIGHT:
A gold Cloche de
Cartier watch with
bell-shaped dial.

Stars and Their Tanks

The Cartier Tank, which is undoubtedly the jeweller's most iconic wristwatch, established itself as the watch of choice for celebrities and statesmen in the mid 20th century. It has been worn on many famous wrists, from Princess Diana to boxer Muhammad Ali, and continues to have close ties with celebrity.

In 1926, actor Rudolph Valentino wore his Cartier Tank while filming *The Son of the Sheik*, utterly ruining the illusion of his Middle Eastern costume. Other Hollywood stars would follow suit, with Clark Gable, Gary Cooper, Greta Garbo and Tallulah Bankhead all owning Tanks. Even in more bohemian circles the stylish timepiece proved to be in demand. Artist Andy Warhol, who pioneered the Pop Art movement, was a fan. He once said, "I don't wear a Tank watch to tell the time. Actually, I never even wind it. I wear a Tank because it's the watch to wear."

The Tank was also popular in the White House. US president John F Kennedy described the model as "France's greatest gift to America since the Statue of Liberty". He owned a gold version, given to him by his wife Jackie Kennedy on their fourth wedding anniversary.

Jackie Kennedy also owned one, gifted to her in 1963 by her brother-in-law Prince Stanislaw Radizwell of Poland. She was rarely seen without the gold Tank on a black lizard strap, which was later put up for auction at Christie's in 2017. It was won by Kim Kardashian, but the reality star later quietly sold it back to Cartier for its archives.

The Cartier Tank has since developed a reputation as the watch of choice for the First Ladies of American politics.

Michelle Obama wore a steel Tank Française in her first official photograph as First Lady in 2009. First Lady Dr Jill Biden also owns a Tank, although she is more often spotted wearing her gold Panthère de Cartier watch.

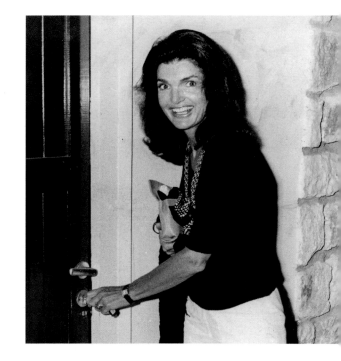

RIGHT:
Former US
First Lady
Jackie Kennedy
photographed
wearing her
Cartier Tank
in 1975.

Mystery Clocks

In addition to its watches, Cartier is also known for a rather novel stationary timekeeper, the Mystery Clock. This horological creation is so named because it appears as though the hands of the clock are floating; seemingly attached to nothing, yet still keeping time.

This clever illusion was first mastered by Jean-Eugène Robert-Houdin in 1845. The Frenchman was a watchmaker, illusionist and inventor whose various mechanical curiosities won him royal patrons and caught the eye, and wallet, of famous American showman P. T. Barnum.

Louis Cartier and Cartier clockmaker Maurice Couët were fascinated with Robert-Houdin and set about making their own mystery clock. The first was launched in 1912 and many more would follow. The maison still produces mystery clocks, and also introduced the illusion to watches such as the Rotonde de Cartier, with floating hand and movements.

So how does it work? Your eyes might say otherwise, but the hands do not float and are instead attached to rotating transparent discs that are imperceptible to the naked eye.

La Chaux-de-Fonds

A new era for Cartier watchmaking arrived in 1972 when the jeweller opened a facility in La Chaux-de-Fonds in Switzerland, a village in the Jura Mountains that is a watchmaking hub.

Up until this point, all of Cartier's watches were produced in France and then equipped with Swiss movements. With the move to Switzerland, Cartier was able to oversee the development of its own movements and build its watches in one place. Over the next three decades, Cartier would forge partnerships with expert watchmaking companies, and

OPPOSITE: A 1923 *Portique* mystery clock on display at a Cartier exhibition in Lisbon's Calouste Gulbenkian Museum in 2007.

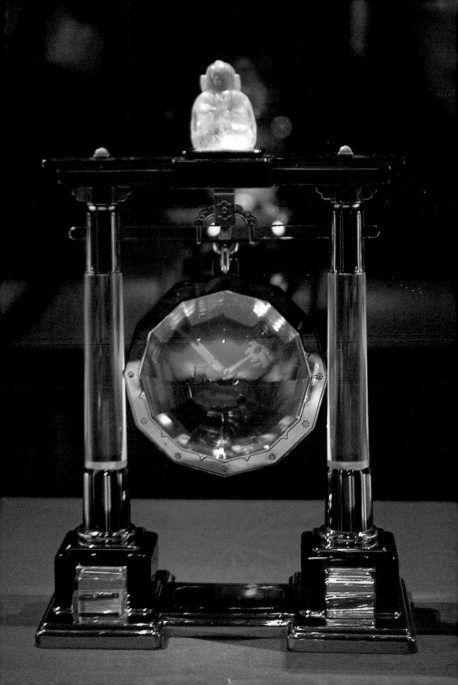

acquire others as needs arose. With every deal struck,
Cartier strengthened its watchmaking capabilities.

This rapid expansion also meant, however, that Cartier's
watchmaking operations were eventually spread out across
several sites in the village. This was addressed in 2001 with
the opening of a single 33,000sqm building designed to
house 1,000 watchmakers practising more than 50 crafts.

The building itself, which is one of the largest fully
integrated watchmaking facilities in Switzerland, is designed
to be at one with the mountains; from the road, it appears
to be wedged into the hillside. Large windows let in lots of
natural light to the almost clinical workshops populated by
workers in white coats.

In 2007 a 3,000sqm wing was created just for Cartier's
research and development projects. It was dubbed the

Think Tank, and more than 100 people could use this space with team members from all areas of the business, such as product development, marketing and creative, coming together to dream up new possibilities. Cartier estimates that its site in La Chaux-de-Fonds now employs 1,200 members of staff from more than 30 different nationalities working in 120 different specialities.

Cartier's presence in La Chaux-de-Fonds continues to grow. Next to the main manufacture is its Maison de Métiers d'Art division, housed on an old renovated farm. Here, its artisans work on fine watchmaking and jewellery making, as well as specialist techniques such as marquetry and enamelling.

ABOVE: Cartier's watchmaking manufacture in Switzerland's La Chaux-de-Fonds.

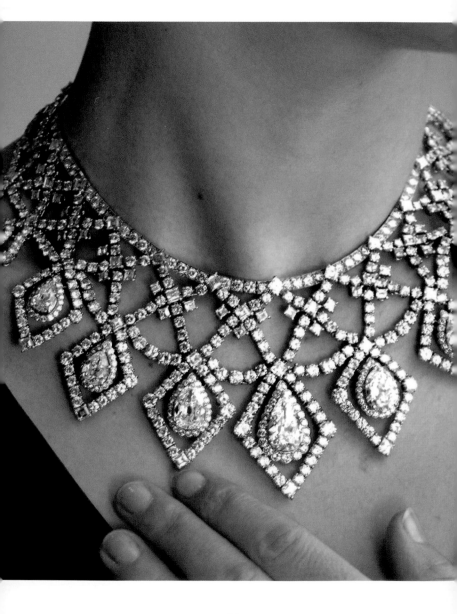

Savoir Faire

Cartier prides itself not just on pioneering designs, but on the quality of its jewels. This might go some way towards explaining why its jewellery performs so well at auction, even a century after leaving the jeweller's bench.

At its workshop in Paris, where it is not unheard of for the creation of a single piece to span a year or more, its jewellery artisans hone skills passed down through generations of craftspeople.

It is here that the jeweller's most exclusive designs, the high-jewellery collections – or *haute joaillerie*, as they are referred to – are crafted, with pieces often clocking up thousands of hours of skilled work.

These jewels will pass through the hands of many Cartier goldsmiths during their journey. Each will enhance it by way of their hard-won speciality, be that gem carving, diamond setting, enamelling or the elegant manipulation of precious metal.

ABOVE: A Cartier necklace set with 100 carats of diamonds, which was once owned by American socialite Anne Moen Bullitt.

Cartier's Jewellery Workshops

In the 9th arrondissement in Paris is a nondescript building that forgoes the pomp and splendour of Cartier's public-facing spaces. While the door might be devoid of red-clad bellboys and the interior scruffier than one might expect, this is where the real magic occurs: the creation of Cartier's high jewellery.

Here, 150 craftspeople, dressed in white lab coats, use loupes and overhead magnifiers to pore over every minute detail of jewels under construction. It is a painstaking process, with hundreds – sometimes thousands – of hours dedicated to the creation of a single piece.

Even just interpreting the sketches that land on their benches can take months of communication between workshop and designer, and the creation of mock ups in clay and wax. Not only does each piece have to look beautiful, it also has to function well – and seem to do so effortlessly. In *haute joaillerie*, the goal is to have as little visible metal as possible, and for jewels to be softly articulated to allow flow of movement. To that end, craftspeople can often spend a fifth of their time working on hidden complications on the backs of jewels.

The artisans in Cartier's Paris workshop employ traditional hand skills that have been passed down through generations, and you will see intergenerational pairings at the benches as apprentice learns from master. The three-floor workshop is split into miniature workshops that specialise in certain craft skills, such as gemstone setting and stone polishing.

Cartier has a second workshop in Paris, near the famous

RIGHT:
A 1912 Cartier
Belle Epoque
diamond brooch,
which sold at
Christie's in 2019
for $10 million.

OVERLEAF:
A rare, late 1920s
Cartier conch
pearl bracelet
once owned by
Queen Victoria
Eugenia of Spain.

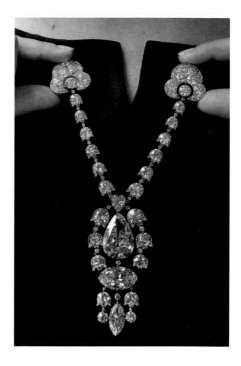

luxury jewellery hub of Place Vendôme. Here, jewellers use modern techniques, such as laser welding, to knit metal together and computer software that allows them to plan out designs.

It also has a substantial workshop in London, which opened in 1922 and remains above its Bond Street store to this day. The London workshop developed its own twist on the Cartier style that would be known as English Artworks, as well as specialising in locally important items such as the tiaras that debutantes were required to wear on entry to British society up until 1958.

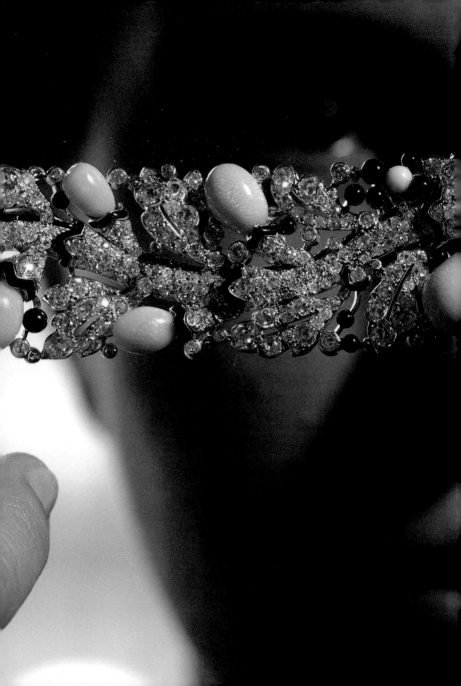

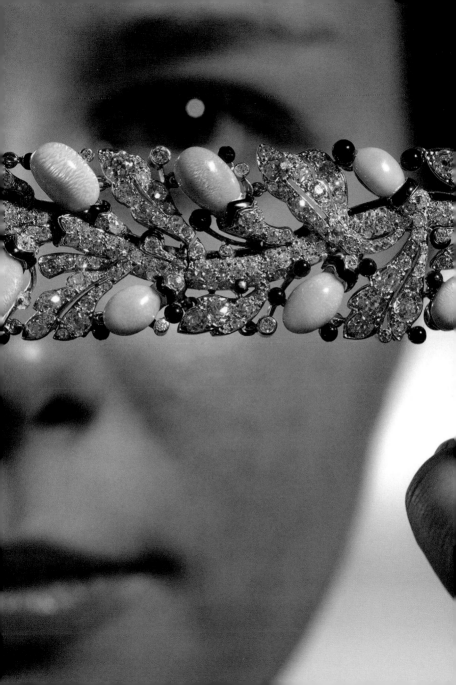

Glyptics

Glyptics refers to the art of carving, engraving and shaping gemstones, or any other material, such as precious wood. It is an ancient skill that was used by the Greeks and Romans to create cameo portraits on shells. It is an artform that was much cherished in 19th-century France, with Napoleon Bonaparte founding an academy dedicated to engraving in Paris in 1805 to further its use.

Glyptics remains a much-cherished skill at Cartier. Carved stones, often taking floral forms or the shape of animals, or gems with images etched on the reverse so that they shine through, are a regular feature in its high-jewellery collections.

In 2010, Cartier approached French master glyptician Philippe Nicolas with a proposal. Having run his own atelier in Paris for 35 years, Nicolas was now considering his legacy and how best to pass his knowledge on to future gemstone carvers; he realised he would need serious means to do so at scale. In exchange for acquiring his atelier, and so gaining exclusive access to his work, Cartier agreed to fund his plans, and it is now one of the only major jewellery houses to have an in-house glyptics workshop.

RIGHT:
A 2011 Cartier Orchid brooch with a 761ct carved rubellite bloom and diamond briolettes.

Fur Setting

A signature of Cartier's *haute joaillerie* is its fur setting. Ever since the Panthère motif first appeared on a Cartier watch in 1914, the maison has sought to make its bejewelled creatures ever more realistic.

Crucial to that is the fur setting. This refers to a special style of setting diamonds and gemstones into the Panthère creations so that the gold and stones mimic the spotted fur of the panthers that inspire them.

It is a craft that unites the skills of three different types of Cartier artisan: gemstone cutters known as lapidarists, the stone setters who fix the gems in place, and the goldsmiths that create the settings.

Each gem is custom cut to just the right size and placed in a bespoke setting. Threads of gold are then used to secure the diamonds and gems in place, before a final smoothing of the metal to ensure a flawless, strokable finish.

RIGHT:
An artisan works on the fur setting of a Panthère brooch in Cartier's Paris workshop in 1989.

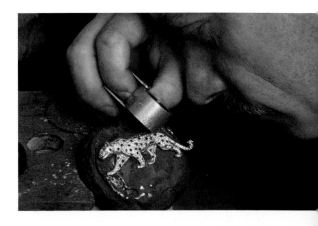

High Jewellery

The Cartier high-jewellery collections are the pinnacle of the maison's achievements, showing off the rarest stones and the most challenging craftsmanship. Just like fashion houses, the jeweller's collections are split into ready to wear (non-limited lines such as the Love bangle) and one-of-a-kind haute couture creations, which are referred to widely as *haute joaillerie.*

These high-jewellery collections will usually be released twice a year, and often timed to coincide with the Couture Week presentations that take place in Paris in January and July each year. This is a time when top clients from around the world fly into the city to view the latest couture creations in both fashion and jewellery.

While each collection will have a theme, the jewels crafted to fill it will be entirely one-off creations. There is a sense of one-upmanship with these launches, as houses seek to catch the attention of wealthy collectors with rare gems, bold designs and new techniques. The jewels carry prices that are reflective of this, with single pieces often costing millions of euros.

Cartier high-jewellery launches are not just simply transactional sessions but legendary events orchestrated to dazzle and delight its best customers, as well as celebrity guests and press. In addition to chic showcases in Paris, the brand will often take the collections further afield for truly special experiences. In 2019, it showcased Magnitude in

OPPOSITE: Panthère de Cartier high-jewellery necklace with strings of sapphire beads and a diamond-set panther.

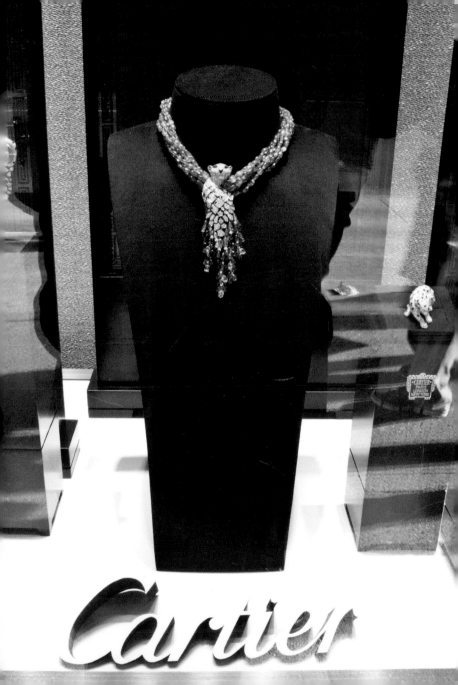

London and hosted a star-studded party in the city. In 2021, the brand launched Sixième Sens in Lake Como with a series of events taking place over two weeks.

Any jewels that aren't sold at these special launch events will then embark on world tours, travelling from boutique to boutique until an owner is found. Often in the world of *haute joaillerie*, there can be fierce competition from collectors. Some houses will allow true VIPs to commit to pieces before they are even made, using painted illustrations, known as gouache, as guides.

ABOVE AND OPPOSITE:
Actresses Fan Bingbing (above) and Monica Bellucci (right) attend the launch party for high-jewellery collection Sortilège de Cartier in Rome in 2011, both wearing Cartier jewels.

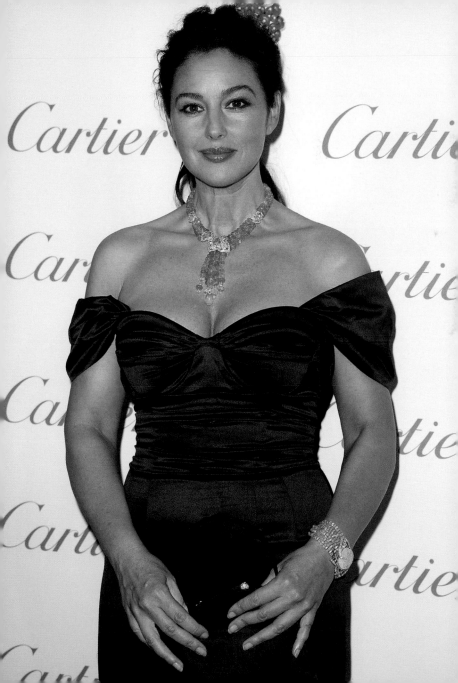

Jeweller to
the Stars

Cartier might have built its reputation on being the 'jeweller of kings' but it has also been jeweller to some of the most famous names in Hollywood and beyond.

Stars have flocked to its red-trimmed boutiques in search of the exquisite and the rare. It has created some of the most famous engagement rings of all time, as well as accepting technical challenges from demanding starlets that have pushed its craftspeople into fresh realms of innovation. Cartier's high jewellery is also regularly spotted on the red carpet, with the firm one of the go-to choices of A-list celebrity stylists.

OPPOSITE: Cartier jewels owned by actress Elizabeth Taylor, including a necklace set with the historic La Peregrina pearl.

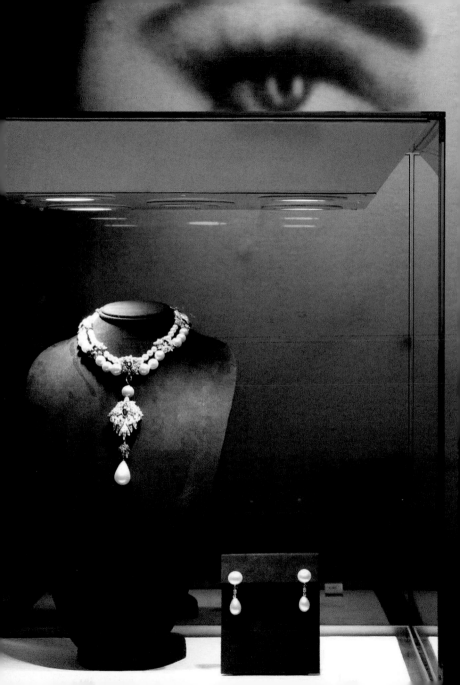

Elizabeth Taylor

Hollywood actress Elizabeth Taylor was one of the most voracious celebrity jewellery collectors of all time – so much so that she even wrote a book about her passion for adornment, titled *My Love Affair With Jewellery*.

While Taylor shopped at many jewellery houses, some of her most spectacular pieces were crafted by Cartier. The actress was famously animated when receiving gifts of jewellery, large or small, and one of these moments was caught on camera as her third husband, Mike Todd, presented her with a Cartier box while poolside in St Jean Cap Ferrat on the French Riviera. Inside the red box, much to the 24-year-old Taylor's obvious delight, was a suite of diamond and ruby jewels that she would wear often over the years.

"Originally, I wore the diamond as a ring, but even for me it was too big, so we had Cartier design a necklace."
Elizabeth Taylor

Taylor married eight times, racking up a substantial collection of engagement rings, including some from Cartier. Her most famous love affair was with the actor Richard Burton, who she married twice, and this union led to some of the most lavish Cartier jewels in her collection. He gifted her the 16th-century La Peregrina pearl that she

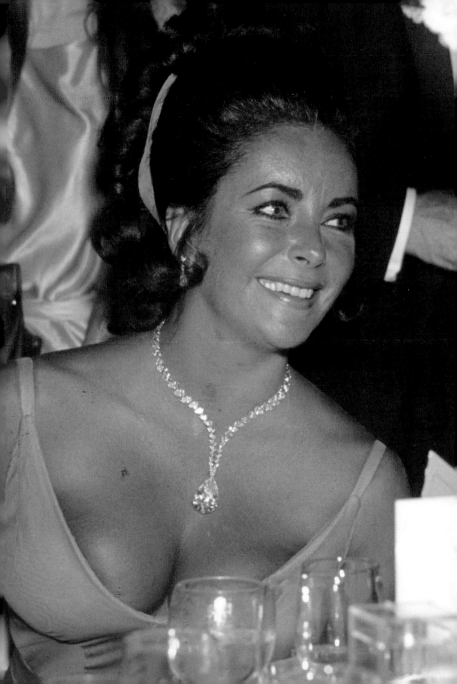

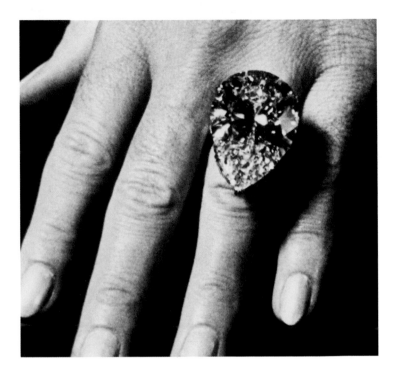

would ask Cartier to set in a spectacular diamond, pearl and ruby necklace in 1969. In 1972, he presented her with a Cartier chain set with a gold, enamel and heart-shaped diamond pendant, first owned by the 17th-century Mughal Emperor Shah Jahangir, who would create the Taj Mahal.

Most spectacular of all was the Taylor-Burton diamond, as it would come to be known. The 69.42-ct pear-shaped diamond, described as the size of a peach pit, was put up for auction in New York in 1969, and Burton set his sights on it as a gift for his wife. The bidding was fierce, reaching the $1 million limit he had given his associate attending the auction for him. There was one subsequent bid,

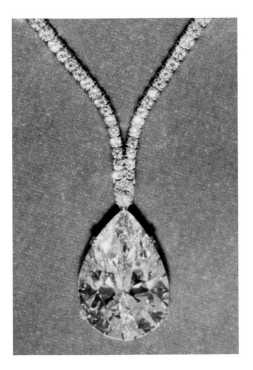

which came from a Cartier representative, and so Burton narrowly missed out. The very next day, an undeterred Burton contacted Cartier to purchase the diamond from the jeweller. It has never been revealed how much he had to pay.

The original plan was to make a ring, but even for Taylor this diamond proved too large to be worn on the hand. It would instead become a necklace, but before work started, the Taylor-Burton diamond was displayed at Cartier's Fifth Avenue store. The diamond's week-long residency drew crowds of more than 6,000 people each day, who all lined up for a glimpse at the famous rock.

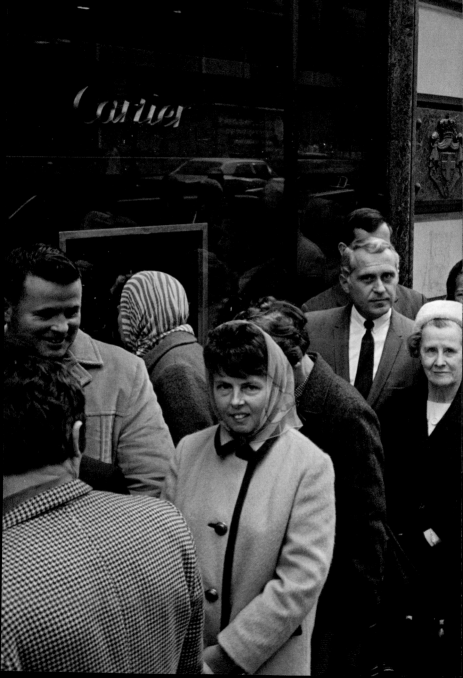

María Félix

Flamboyant Mexican actress María Félix, known for her femme fatale roles in Spanish-language cinema, was not just a fan of Cartier's jewellery, but also a serious collector, collaborator and muse.

Her style was as bold and colourful as her lifestyle. One famous story recounts the time in 1975 when Félix burst into Cartier's flagship store in Paris carrying a live baby crocodile in an aquarium, as a reference for an item she wanted to commission.

Based on this encounter, Cartier created an enormous necklace with two fully articulated gold crocodiles, set with 1,023 yellow diamonds and 1,060 emeralds. The crocodiles could also be detached and worn separately as brooches.

"Some friends told me that pearls make people cry. The only pearls that have made me cry are false pearls."
María Félix

The necklace is now owned by the Cartier Collection, an archive of important Cartier jewels bought back by the house, and has only been worn by one other woman. At Cannes Film Festival in 2006, actress Monica Bellucci wore it with a white shirt on the red carpet. Another of Félix's famous Cartier commissions was a snake. In 1966, the

actress asked the jeweller to create a necklace that was true
to life in terms of size and movement.

It took Cartier's craftspeople two years to fulfil her wishes.
What they came up with was a 22-in long fully flexible
design crafted in gold and platinum and set with 2,473
diamonds, weighing 178.21cts. In a nod to the Mexican
flag, the underbelly of the snake was decorated with green,
black and red enamel.

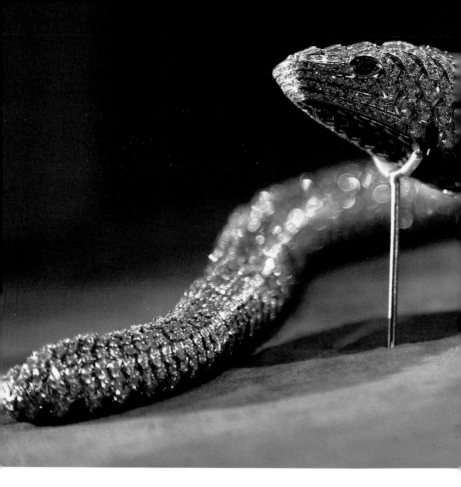

Félix died in 2002, and four years later Cartier paid tribute to her with a collection of jewellery inspired by her exotic tastes. It was called La Doña de Cartier, referencing one of Félix's most famous roles in the 1943 film *Doña Bárbara*. It comprised four high-jewellery creations featuring crocodile motifs set with rare Colombian emeralds. To ensure that

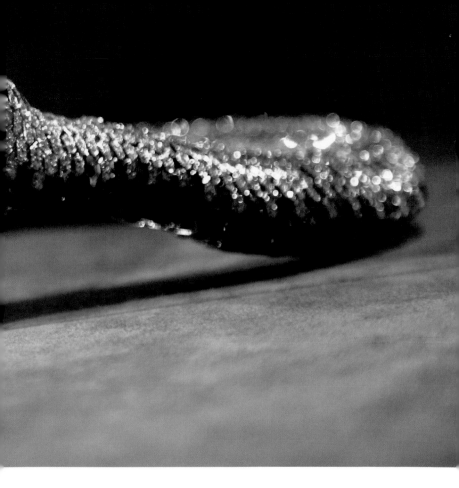

Félix would have approved, Cartier employed the same craftsman who had worked on her crocodile necklace to create these new pieces.

ABOVE: It took Cartier two years to create this fully articulated, diamond-set snake for María Félix in the 1960s.

Grace Kelly

Grace Kelly only married once, but she had two engagement rings – and both were created by Cartier. The actress was introduced to the maison by director Alfred Hitchcock, who was himself a great lover of jewellery, and it would spark a long relationship between Kelly and the jeweller.

When Kelly was in the south of France in 1955 promoting her appearance in one of Hitchcock's films, *To Catch a Thief*, at Cannes Film Festival, she caught the eye of Prince Rainier III of Monaco. As the story goes, the Prince arranged for his home to be used as the location of a photoshoot just so he could meet her. The attraction was mutual and later that same year, Prince Rainier proposed to Kelly at her home in Philadelphia in the United States. The ring he chose was an eternity band of diamonds and rubies, which he bought at Cartier.

> "I favour pearls on screen and in my private life."
> **Grace Kelly**

Though this was the ring he proposed with, it is perhaps not the Cartier engagement ring that is most associated with Grace Kelly. A second ring would come later, when the star was filming *High Society*, which would be her last Hollywood role before she took up her royal duties as Princess Grace of Monaco. During production, Rainier

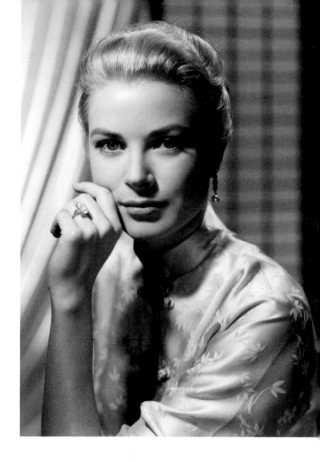

heard that the film's costume designer was planning to source a fake diamond ring for Kelly's eccentric socialite character. He offered up an alternative plan: he would buy her a second real engagement ring that could be worn in the film. The ring he selected was far more lavish than his original choice. Returning to Cartier, he selected a ring set with a huge 10.48ct emerald-cut diamond flanked by two smaller baguette-cut diamonds. Watch the film, and you

BELOW:
Grace Kelly and Prince Rainier III
of Monaco pose for a photo with
the actress's parents, Margaret
and Jack Kelly, to celebrate their
engagement.

OPPOSITE:
A scene from *High Society* in which
Grace Kelly wears her Cartier
engagement ring.

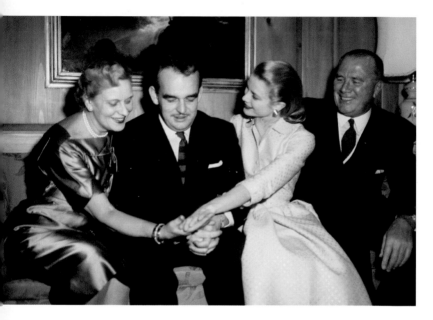

will see it glinting at the camera throughout. At Cartier's
flagship store in New York, known as the Cartier Mansion,
the jeweller has paid tribute to its relationship with Kelly
by naming an area of the store after her. The Princess Grace
of Monaco Salon is decorated with images of her as well as
heraldry of Monaco, and it is where you will find Cartier's
contemporary collection of engagement rings.

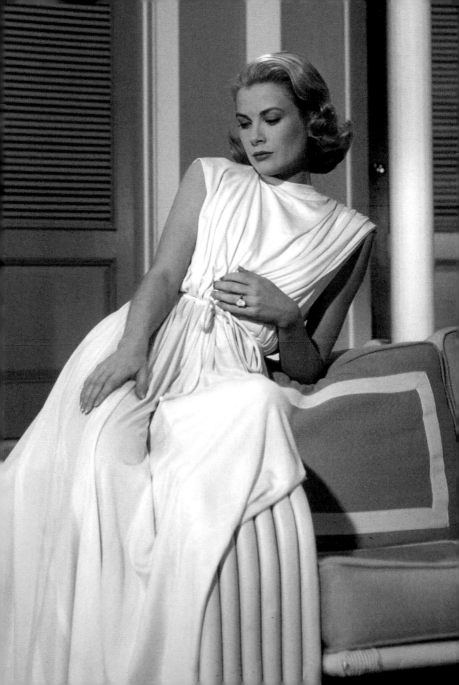

Wallis Simpson

Some love affairs are legendary; none more so than that of the Duke and Duchess of Windsor. The Duke famously abdicated from his role as Britain's King Edward VIII in 1936 so that he could marry the future Duchess, a twice-divorced American by the name of Wallis Simpson whom the royal family did not approve of. The union would also have caused a constitutional crisis.

Those close to Simpson recall her being both intelligent and elegant, with a lively sense of humour and a big heart. She also had a voracious appetite for jewels, one that the Duke was only too keen to pander to, starting with an emerald and diamond engagement ring from Cartier.

"I'm not a beautiful woman. I'm nothing to look at, so the only thing I can do is dress better than anyone else."
Wallis Simpson

The 19.77ct emerald was in fact half of a larger stone that had once belonged to the Great Mughal, an Indian dynasty. Jacques Cartier bought it whole, but was forced – much to his distaste – to split it in two, recognising that there was not the client out there in the 1930s with pockets deep enough to buy it whole.

OPPOSITE: The Duchess of Windsor Wallis Simpson, pictured wearing her emerald Cartier engagement ring.

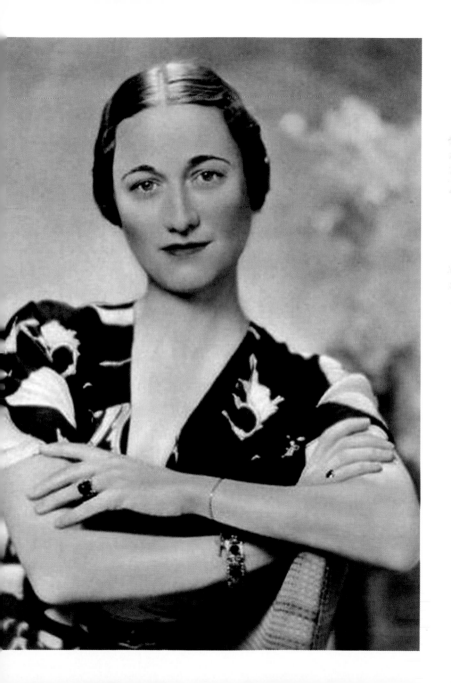

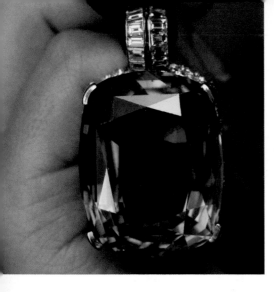

OPPOSITE: The Duke of Windsor ordered this Flamingo brooch set with diamonds, emeralds, rubies, sapphires and a citrine for the Duchess's 40th birthday.

LEFT: Cartier created this pendant, set with a 202ct sapphire, for the Windsors in 1951.

When the Windsors married, they did so with platinum Cartier wedding bands. That same year, Edward commissioned a brooch from Cartier that would interlock their initials 'W' and 'E' to spell out 'we' in rubies and sapphires. It was one of many Cartier purchases he would make for Simpson that year, and the pair would go on to build on their Cartier collection for years to come.

In the 21st century, many of Simpson's jewels have come to auction. These have included Cartier designs such as her favourite diamond, ruby, emerald and sapphire flamingo brooch ordered by Edward in 1940, and an onyx and diamond Panthère bracelet designed by Cartier's Jeanne Toussaint.

Simpson and Toussaint were friends. Both were regulars on the fashionable Café Society scene in Paris, and they shared a love for big cats and jewels. Simpson bought many of the Cartier designer's pieces, and is credited for popularising the Panthère.

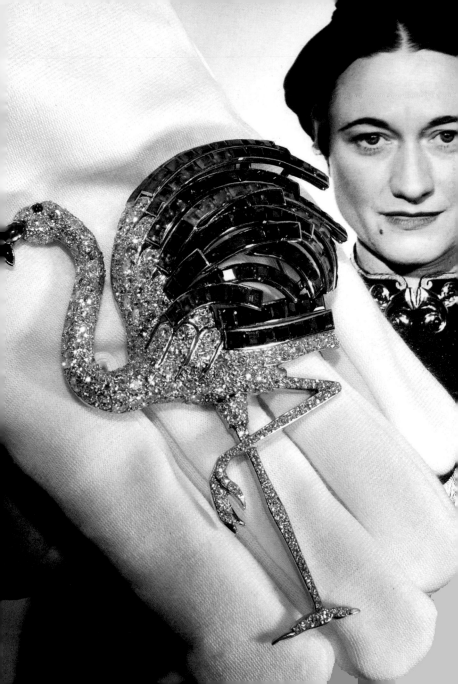

TOP:
A Cartier diamond bracelet with gem-set cross charms belonging to the Duchess of Windsor.

ABOVE LEFT:
A gold Cartier cigarette case bought by the Windsors for their friend Herman Rogers in 1937.

ABOVE RIGHT:
A brooch with the Windsors' initials 'W' and 'E' in rubies and sapphires, made in the early 1930s.

OPPOSITE:
This Cartier Panthère bracelet owned by Wallis Simpson sold for a record-breaking £4.5 million at Sotheby's in 2010.

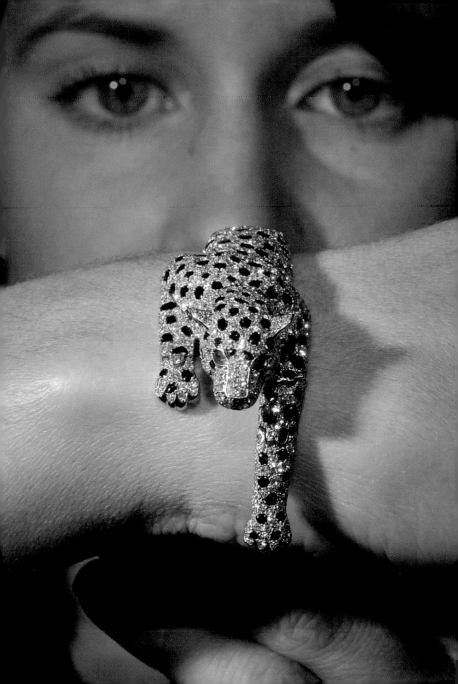

Red-Carpet Rocks

No red-carpet event is complete without the glitter of a Cartier jewel. The maison has long been the jeweller of choice for many a starlet walking the red carpet who finds themselves in need of some borrowed bling.

Cartier jewels always lend themselves well to the moment, whether a slick shimmer of diamonds or a dramatic collier in the style of the ruby Reine Makeda de Cartier necklace worn by Jane Fonda at Cannes Film Festival in 2015.

It is not always just the newest high-jewellery collections that are rolled out for the red carpet. Some stars prefer something with a little history, such as Uma Thurman who accessorised the shoulder of a white dress at the 2016 Met Gala with a diamond bird brooch created by Jeanne Toussaint in 1948.

Though not as glaringly obvious as the flashbulb-bouncing diamonds, Cartier watches also tend to make the invite list for the most exclusive red-carpet events, slipped beneath the tuxedos of male stars. The rising trend for men to liven up tuxedos with precious brooches has also led to famous leading men, including Timothée Chalamet and Rami Malek, wearing Cartier pins.

OPPOSITE
TOP LEFT:
Timothée Chalamet wore a 1955 vintage ruby and diamond Cartier brooch to the 2020 Academy Awards.

OPPOSITE
TOP RIGHT:
Jennifer Lopez at the Academy Awards in 2010 wearing Cartier earrings.

OPPOSITE
BELOW:
Jessica Alba wears Cartier earrings to the Academy Awards in 2008.

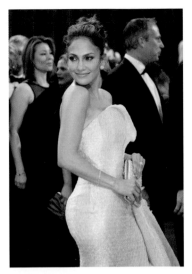

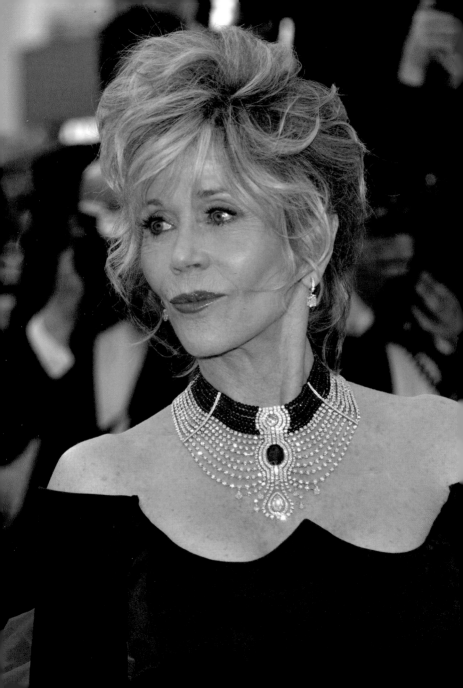

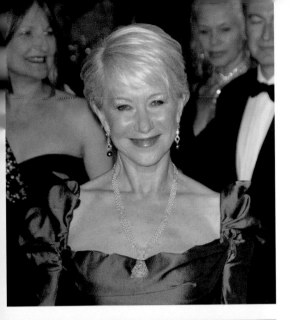

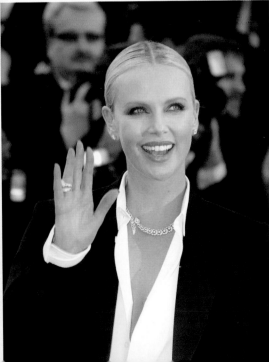

OPPOSITE:
Jane Fonda
wears the ruby
and diamond
Reine Makéda de
Cartier necklace
at Cannes Film
Festival in 2015.

TOP:
Helen Mirren
wears an antique
platinum,
diamond and
pearl necklace
from the Cartier
Collection
to the 2011
Academy Awards.

BELOW:
Charlize Theron
wears Cartier
diamond jewels to
the 2016 Cannes
Film Festival.

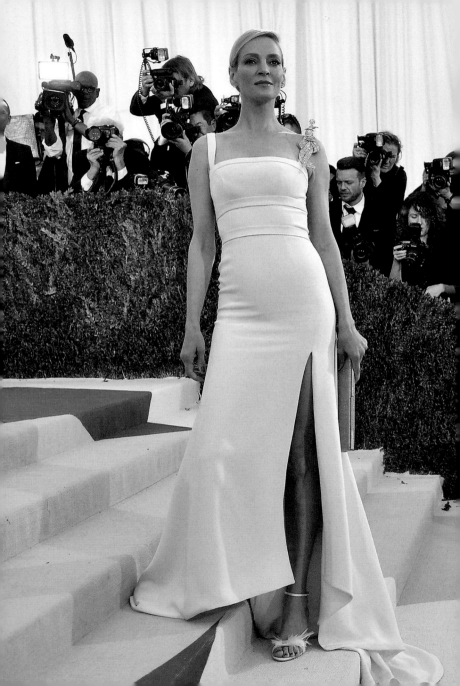

The Icons

Cartier has become shorthand for luxury. While its one-of-a-kind high-jewellery creations have won it prestige and awe, it is the repeatable collections that have secured it fame and fortune. Some of these popular creations, such as the gold Love bangle or a slimline Tank watch, are instantly recognisable by those in the know.

These precious adornments have become must-haves for well-heeled shoppers pursuing a luxury accessory collection, and sell by the thousand. Cartier's most iconic designs not only have a style that is evergreen, but also tend to hold their value, making them a wise investment as well as a sartorial statement.

PREVIOUS:
Uma Thurman at the Met Gala in 2016 wearing a Cartier diamond bird brooch created by Jeanne Toussaint in 1948.

OPPOSITE:
A Cartier window display showing its iconic red boxes and leopard.

Love Bracelet

The Cartier Love bracelet is one of the maison's most iconic jewellery designs. In a nod to the permanence of happily ever after romances, those who wish to wear one must forgo the ability to slip it off at the end of the day. Instead, the gold bracelet is screwed in place on the wrist.

When Cartier first launched the provocative Love bracelet in 1969, it added a caveat to this already unusual jewel. The bracelets were sold exclusively in pairs to lovers; you could not walk into a store and buy one for yourself, as you can now.

LEFT:
A man wears a stack of gold Cartier Love bracelets.

To bring some attention to this new form of commitment jewellery, it employed the help of famous lovers. Cartier targeted 25 couples it believed were the epitome of romance and gifted them a set of bangles. The list included the Duke and Duchess of Windsor, Elizabeth Taylor and Richard Burton, and Nancy and Frank Sinatra.

Others soon followed. Actress Ali McGraw famously wore her Cartier Love bracelet, gifted to her by husband Robert Evans, throughout the filming of the 1972 film *The Getaway*. In it she starred alongside Steve McQueen, who would become her next husband; by which point one would imagine the tiny gold vermeil screwdriver sold with every Love bangle was utilised to remove it.

Though the Love bracelet is worn as a celebration of relationships, it was in fact the destruction of one that led to its creation. Italian jewellery designer Aldo Cipullo was living in New York when he had his heart broken. In the middle of the night, full of angst, he railed against his fate by imagining a jewel that could lock his retreating lover to him. One that could not be shrugged off as easily as he had been that night.

The gold bracelet he designed, with a soft oval shape to ensure comfort, was adorned with decorative screw heads inspired by cufflinks and chastity belts, plus one functional screw to lock it in place. At the time, Cipullo was working for Tiffany & Co. and first touted the design to his employer. It turned him down, prompting him to take the design to Cartier, and an icon was born.

Cartier Love bracelets are engraved with a serial number that is kept on file for proof of authenticity.

Tutti Frutti

Cartier's Tutti Frutti designs can be recognised by their carved emeralds, sapphires and rubies that take the form of leaves, berries or flowers, set in diamond-studded platinum. The use of these gems, which originated from traditional Indian jewellery, was inspired by Jacques Cartier's travels to India in the early 20th century, and subsequent collaborations with the country's maharajas.

The first Tutti Frutti jewel ever created was a necklace designed by Pierre Cartier in 1901 for Britain's Queen Alexandra, to be worn with Indian gowns she received as a gift. However, it wasn't until the Art Deco period of the 1920s that they became a regular feature in Cartier collections.

Bracelets are the most popular Tutti Frutti jewels, and have previously sold at auction for more than $2 million. Other styles of jewels have also been created, such as a tiara for England's Countess Edwina Mountbatten. It was considered

LEFT: This Cartier Tutti Frutti bracelet sold at Sotheby's in 2017 for HK$13.9 million.

OPPOSITE: A Ballon Bleu de Cartier gold watch with diamond bezel.

such a special piece that the British government put an export ban on it when it was sold in 2004. A decade later, a bargain hunter bought a Tutti Frutti brooch at a British flea market for £38 and later sold it for more than £10,800.

Ballon Bleu

Cartier's watches are known for their provocative case shapes, which is perhaps why the jeweller waited until 2007 to launch the Ballon Bleu de Cartier. At this time, the use of a more traditional round dial felt fresh and innovative. This round watch, however, has a twist. Rather than a traditional flat sapphire glass covering the dial, Cartier opted for a domed glass. The other hallmark of this design is its unusual crown, which is integrated within the bezel and tipped with a blue sapphire cabochon.

The watch was an instant hit when it was first launched. Famous fans include Johnny Depp and Kate Middleton, the Duchess of Cambridge.

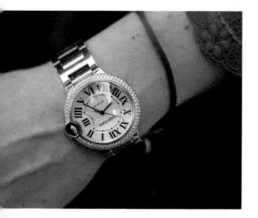

Over the years, many versions of the Ballon Bleu have been released with diamond bezels, different dial colours or strap options. There is also now the Ballon Blanc de Cartier, which swaps the sapphire crown for a brilliant-cut diamond at four o'clock.

Tank

With its classic Roman numeral dial, elegant case shape and crown tipped with a sapphire cabochon, the Cartier Tank is one of the world's most sought-after dress watches for all genders.

The signature motif of the Tank design, which was inspired by Renault FT-17 tanks that Louis Cartier saw on the Front while fighting in World War I, is the watch's parallel *brancards*. These bars of metal running perpendicular to the ends of the case are used to fix the straps or metal bracelets.

There have been many twists to the design over the years, such as the luxurious elongated Tank Américaine that was launched in 1989 with a gold bracelet, and the entry-level Tank Must de Cartier, which made it accessible to a wider audience on its launch in 1977. The latter line was revived in 2021, proving the design's longevity, and featured a SolarBeat movement that is powered by the sun.

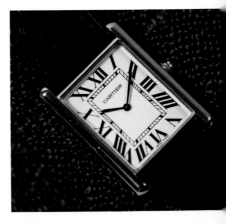

Pasha

The Pasha de Cartier watch collection, which was launched in 1985 and had a reboot in 2020, is named after a timepiece commissioned by the Pasha of Marrakesh, Thami El Glaoui, in the early 1930s. The ruler of Marrakesh approached Cartier in search of a waterproof watch that he

could wear while swimming that would also look elegant enough to be worn to official functions.

The first Pasha watches were launched in the 1980s were predominantly aimed at men, with newspaper ads describing them as 'the big watch', but women would soon seek it, too.

The watches have a round case with a broad bezel, and a sapphire cabochon-tipped screw-down crown cap, fixed with a dainty chain to protect against water getting into the watch movement. Another design quirk that makes it stand out is the minute markers, which are not placed in a circle edging the dial, as with most watches, but on a square track at the centre.

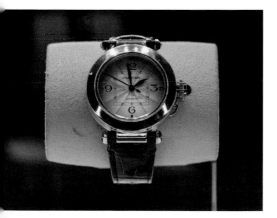

OPPOSITE: A classic Cartier Tank on an alligator strap.

LEFT: A rose gold Pasha de Cartier watch with sapphire-tipped crown.

Santos

The Santos de Cartier collection is inspired by the jeweller's first ever men's wristwatch, which was created in 1904 for Brazilian aviator Alberto Santos-Dumont, a friend of Louis

Cartier. It was a landmark moment for the Parisian brand and by 1911 it had launched a commercial collection named after the pilot.

An enduring feature of the design is the visible screw heads on the bezel. Louis Cartier had specifically made a feature of these industrial touches to differentiate this man's watch from the dress watches worn by women at the time. In 1978, Cartier launched a two-tone design in gold and steel that carried the screw heads into the bracelet.

LEFT: A gold and steel Santos de Cartier watch.

Santos continues to be one of Cartier's most popular models more than a century later, favoured for its sleek look. Elegantly stretched Roman numerals decorate a square dial with a square minutes track. The evolution of the Santos line has led to watches being designed for women, as well as the Santos-Dumont line of more accessibly priced versions with quartz movements.

Juste un Clou

Juste un clou can be translated from French as 'just a nail' and that's exactly what this jewel is. It was first created in 1971 by Aldo Cipullo, the same designer responsible for the

Love bracelet, and was originally titled the Nail Bracelet. It is a simple concept, but one that is an edgy style statement with punk undertones: a solid gold nail shaped to fit around a wrist, finger or neck. The pure lines of the design are embellished with five ridges just below the nail head, in reference to those often seen on the real thing, and it has a faceted diamond-shaped tip.

RIGHT: An 18ct gold Cartier Juste en Clou bracelet.

Juste en Clou was given its current name when the collection was relaunched in 2012, and it has become a Cartier icon that is instantly recognisable. The bracelet remains the most popular design within the collection, but it has expanded to include numerous jewellery styles and ultra-luxe diamond-set editions.

Trinity

Louis Cartier created the first Trinity ring in 1924 at the behest of French playwright and poet Jean Cocteau, who wore two of them on his pinky finger. The design offered a surprising twist on the simple gold band by taking three bands, each a different colour of gold – yellow, white and

rose – and interlocking them together. The Trinity ring could be viewed as a bold, less intricate take on old French gimlet rings, which were made up of two or more separate hoops that morph into one. Rather than trying to hide its multiple bands, the Trinity celebrates them. Like gimlet rings, Cartier's design carries a symbolic message, with the three bands representing fidelity, friendship and love.

LEFT: A Cartier Trinity ring with white gold, yellow gold and rose gold interlocking bands.

The Trinity collection has since been widened to include all manner of jewels, including a popular line of bracelets, but the ring remains the most iconic design. Over the years, alternative design flourishes have crept in, such as diamond pavé or black ceramic bands.

Crash

One of the most striking watches created by Cartier is the Crash, a fantastical model dreamed up by Jean-Jacques Cartier, son of Jacques Cartier, in London in 1967. With a twisted watch dial that appears to be melting, many people thought that the inspiration came from Salvador Dalí's

surrealist clocks in his work *The Persistence of Memory*. However, folklore suggests otherwise.

One legend is that its design was inspired by a customer's Cartier Baignoire watch that had been damaged in a car crash and was taken into the jeweller's Bond Street store in London. Another theory is that the kooky shape was simply a reaction to the experimental nature of the rebellious Swinging Sixties.

RIGHT: A dress version of the Cartier Crash, c.2018.

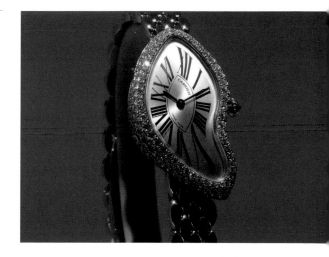

Either way, the distorted oval case – which Cartier claims was the first ever asymmetric watch dial – is certainly a symbol of creative freedom, and has been seen on the wrists of artists including Kanye West and Jay-Z. Over the decades, Cartier's production of Crash watches has been few and far between, so collectors must scour the secondary market in hope of a rare listing. This scarcity has accelerated prices, with a 1970 model selling for more than $885,000 at Sotheby's in 2021.

Panthère

The panther is entirely synonymous with Cartier. The majestic big cat prowls through its advertising and abounds in its stores, and it has also inspired some of the most iconic jewellery and watches at the house.

The animal's prominence in the designs at Cartier is down to creative director Jeanne Toussaint, who herself was nicknamed Panther or Panpan. It is said that a desire to translate the animal into jewels struck her while on safari with Louis Cartier. On seeing one of these creatures in the wild, she cried, "Emeralds, onyx, diamonds, a brooch!"

The Panthère motif, as it would be named, first appeared on a ladies' watch in 1914, with its spots realised in diamonds and ebony. That same year, a panther would appear submissive and collared at the feet of a woman in an illustrative ad for the maison.

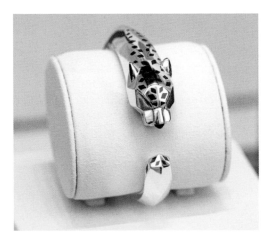

LEFT: A gold Cartier Panthère bracelet decorated with black enamel.

OPPOSITE: A gold Panthère de Cartier watch.

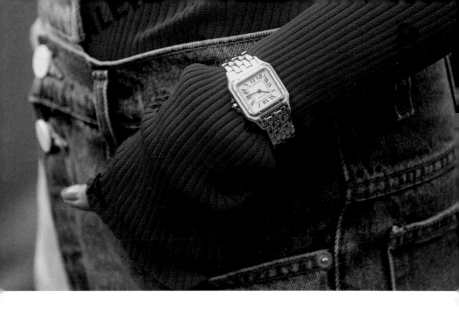

One of the most famous Cartier Panthère designs is a bracelet that features a lifelike panther wrapped around the wrist, with diamonds and onyx set in gold using a proprietary technique called Fur Setting. Vintage examples of these have been known to sell for millions of dollars, but you can find the precious beast within Cartier's contemporary gold jewellery collections in myriad poses – minus the Fur Setting – for a few thousand dollars.

Cartier's love affair with panthers also inspired the Panthère jewellery watch collection, which was first launched in 1983. It was an instant hit with the art crowd. These sleek dress watches, crafted in gold or stainless steel, pay homage to the Santos timepieces, with square dials decorated with Roman numerals, edged by a bold bezel with visible screwheads. What sets the Panthère watches apart is a super-flexible metal bracelet inspired by the fluid movement of the big cat.

The Cartier Experience

P art of what draws so many to Cartier, beyond the jewels and the watches, is the experience of shopping with the brand. The jeweller has created a signature blend of luxury and aspiration that flows through its boutiques and branding.

From the signature red of its highly desirable boxes to the fully outfitted Cartier bellboys ready to hold open the door for you, every element has been carefully thought through. Cartier's network of boutiques now stretches around the globe, from its spiritual home in Place Vendôme to America, Asia and beyond. The company has also capitalised on its brand, creating lifestyle products, such as perfumes and handbags.

The Cartier experience stretches far beyond its stores. Jewels and timepieces will often be passed down through generations, or auctioned off for spectacular sums.

OPPOSITE: Miniature Cartier bellboys trim the tree in a festive store display at a boutique in Moscow.

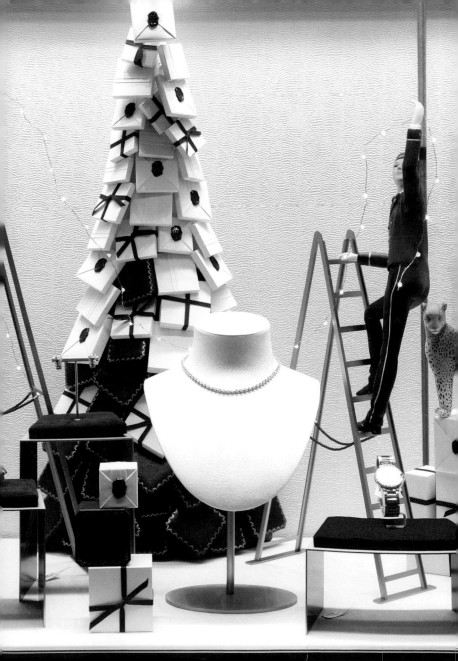

Building a Retail Empire

The Cartier retail empire first took root in 1859 with a single boutique in Paris. Today, there are more than 260 of its stores in 60 countries across the globe. The stores are temples to luxury, with exquisite furnishings and attentive store staff always on hand to offer advice, and perhaps a glass of champagne. These boutiques are where you can truly immerse yourself in the house of Cartier, with all the watch and jewellery collections brought together under one roof.

Though the stores are united by uniform standards of customer service, each boutique has its own personality. The Cartier flagship store in London, for example, nods to British culture with artistic installations, such as a hanging glass sculpture created by French maker Mydriaz that is reminiscent of hats worn to Ascot, the famous English horse race and society event.

The London store, on the city's Bond Street, reopened in 2019 after being renovated and expanded. It is one of the biggest Cartier boutiques in the world, spanning 7,275sq ft over three floors, and was masterminded by French designer Bruno Moinard.

Another flagship Cartier store can be found in Paris, the city where it all began, on the famous luxury jewellery hub Place Vendôme, a stone's throw from the Ritz hotel. This Paris store also reopened after renovations in 2019, and while its British counterpart did so with a plush luxury look, the French flagship was decorated by interior designer Laura

OPPOSITE: Cartier flags fly outside a store in Baku, Azerbaijan.

Gonzalez with a slightly different, more bohemian style to fit the city.

In Hong Kong, Cartier chose to decorate the façade of its store in the city's Tsim Sha Tsui with a tiled design that referenced the roof tiles used in traditional Chinese homes. Within the three-storey boutique, which was also designed by Moinard, there are more references to the city: bamboo motif chandeliers and fixtures, and a bas-relief sculpture of a panther overlooking Victoria Harbour from the top of Mount Austin, a local beauty spot known as The Peak.

BELOW: The Cartier store on Place Vendôme in Paris.

OPPOSITE: Place Vendôme is a hub for luxury jewellery houses.

The New York Flagship

Another of Cartier's flagship stores can be found on New York's Fifth Avenue, and this one has a fascinating origin story.

When American financier Morton F Plant put his property on the corner of Fifth Avenue and 52nd Street up for sale in 1916, it was described by *The New York Times* as "one of the finest and newest of the expensive residences". The Manhattan mansion was built in the Neo-Renaissance style with an ornate façade that has many windows on both sides, decorative balustrades and pilasters, and an attic level hidden by an artistic frieze. It was originally designed as two conjoined residences when it was completed in 1905.

Just as Plant was on the hunt for a buyer for his New York home, Pierre Cartier was scouring the city for a location for a new boutique, and he instantly fell for Plant's grand building. It was on the market for $1 million.

While Pierre would get his wish, he would not need to write a cheque for the million. Instead, he managed to pay for the mansion with a string of pearls. Plant had a young wife named Maisie who had become enchanted with a double string of natural pearls – incredibly rare

OPPOSITE: Cartier's New York flagship store on the city's Fifth Avenue, known as the Cartier Mansion.

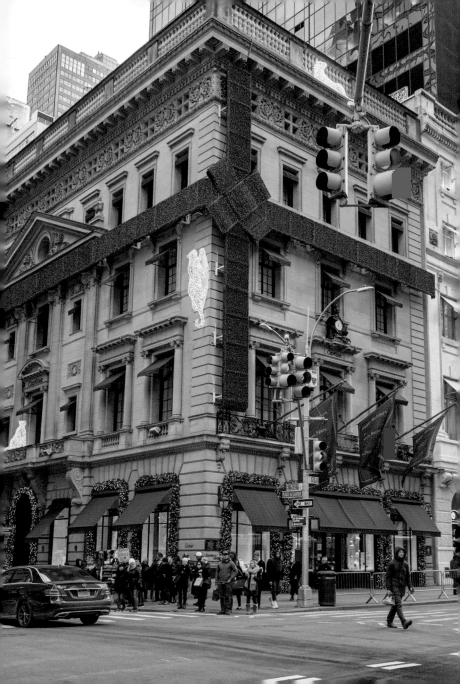

finds. Pierre, noting that the value of the necklace was close to the asking price for the building, suggested a trade.

After the deal was done in 1917, Pierre hired William Welles Bosworth, an architect trusted by the legendary New York family of Rockefeller, to transform the space into the Cartier Mansion. Though the interior changed, the exterior of the building was preserved – and remains so to this day. As other mansions on the so-called Millionaire's Row were levelled and replaced with contemporary architecture, Cartier held firm and the building is now the last of those mansions to remain.

In 2016, the Cartier Mansion reopened after a renovation that had lasted two-and-a-half years. The store still retains the feel of a stately home, with its vast insides split into smaller salons named after some of its most legendary patrons: Andy Warhol, Grace Kelly, Elizabeth Taylor and Gary Cooper. Stepping inside is to find yourself somewhat transported between old-world New York glamour and slick, modern luxury retail.

OPPOSITE: A
Cartier store in St
Petersburg, Russia.

ABOVE: Cartier's
boutique in Tokyo's
upmarket Ginza
shopping district.

RIGHT: A Cartier
boutique near
the Monte Carlo
Casino in Monaco.

OVERLEAF: The three-
floor flagship Cartier
store on London's
Bond Street.

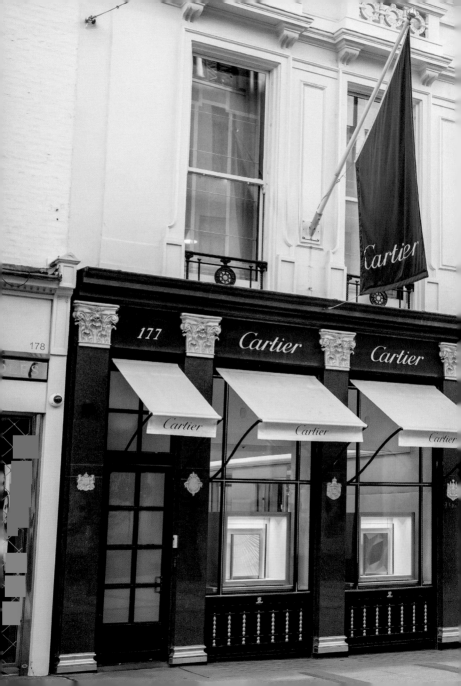

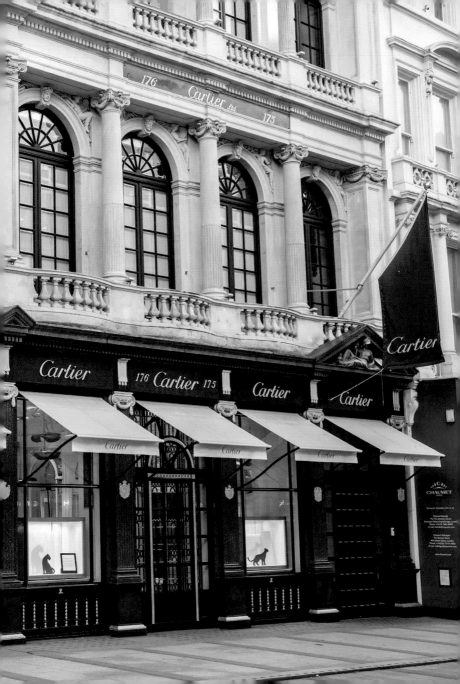

DRIVE DE CARTIER

Cartier's Famous Red Box

Cartier has described its iconic jewellery boxes as the "spirit" of the brand, and, indeed, the red and gold couriers of its jewels and watches have become almost as desirable as what lies within.

The design dates back to the early 20th century. The luxurious leather boxes, square or rectangular in shape, have filed-down corners in the style of the facets of a gemstone. The tops are decorated with a golden frieze of a garland – a signature motif Cartier has used in its jewels since the 1890s.

The most iconic element of these boxes is perhaps their bright red colour. This became the official shade of the house in the 1930s – up until then, its boxes had been available in black, olive or rose hues.

Cartier's red boxes have become so popular that they have inspired myriad branding moments, from filling the window displays of its stores to inspiring the design of its Guirlande de Cartier leather bags. In 2017, the jeweller created an iconic Cartier red box large enough to house a cinema, allowing guests at locations in Australia and Thailand to step within it to watch films about the maison, attended to by Cartier bellboys proffering popcorn.

OPPOSITE: A window display at a Cartier store in Hong Kong in 2016.

Meet the Bellboys

White gloves, red jackets with shiny brass buttons, brimless caps embroidered in gold: this is the uniform of Cartier's legendary bellboys.

Inspired by bellhops at luxury hotels, Cartier created roles within its stores for uniformed helpers who would be on hand to open doors, carry bags to waiting transportation and generally provide a white-glove service for its best customers. For its most important clients, bellboys will even deliver purchases to their homes, and they can regularly be spotted at VIP events bearing trays of champagne flutes. Though such formalities might feel like a hangover from a bygone era, and purposely so, it is a much-loved pillar of the Cartier experience.

The image of the Cartier bellboy has become iconic, and very much part of the brand. Much like the Panthère, you will see caricatures of the bellboys in window displays and marketing materials. You can also buy gifts inspired by them, such as Cartier keyrings in the form of bellboys carrying a diamond on a tray.

OPPOSITE: A Cartier bellboy at an event in Dubai in 2010.

RIGHT: Actress Rosario Dawson hugs a bellboy at the 2007 launch party for the Cartier Charity Love Bracelet, held at the Cartier Mansion in New York.

Beyond Jewels and Watches

In 1972, Cartier Paris was bought by businessman Robert Hocq, backed by a group of investors. At the time, the business was split in three: Cartier Paris, Cartier London and Cartier New York. He would go on to buy all three and reunite them as one.

Part of Hocq's strategy was to launch an affordable sub-brand, called Les Must de Cartier. The name was inspired by a colleague who enthusiastically said one day, "Cartier, it's a must!"

As well as offering more accessibly priced versions of its watches and jewellery, it also included a selection of leather goods. Handbags, wallets, briefcases – even full-sized golf bags – were made in a signature shade of burgundy leather and stamped with an interlocking double C logo.

By the 1980s, Cartier's leather business was going strong, and it decided to expand its lifestyle offering with some new additions. In 1981, it debuted its first perfume, titled Must de Cartier, a sensuous blend of vanilla and jasmine. In 1983, it launched two eyewear collections, Les Must and Vendôme de Cartier.

Cartier has continued to develop its accessory lines, with several scents now available to buy in ornate bottles, including an exclusive line of what it terms 'high perfume'. Its popular sunglasses are sold alongside scarves and belts, as well as homewares, stationery and other gifts.

The leather bags produced by Cartier have proved to be increasingly popular. The classic burgundy Must de Cartier

lines are still available, as well as plain black leather versions. This is supplemented by seasonal collections that take inspiration from some of the brand's archives. One popular leather collection is Guirlande de Cartier, with bright red bags and small leather goods edged with golden garlands in homage to the jeweller's famous boxes. Panthère de Cartier, meanwhile, is a sleek minimalist style embellished with clasps that take their form from its famous Panthère jewels.

Cartier at Auction

Cartier consistently hits the headlines for record-breaking prices at auction. The provenance of the historied maison and its famous collectors tends to inflate hammer prices already driven sky high by the value of the rare gems or exquisite horological craftsmanship.

Famous sales to have whipped up international frenzy include the 2020 sale of a 1930 Tutti Frutti bracelet, an Indian-inspired Art Deco design starring carved rubies, emeralds and sapphires. It had been estimated to sell for between $600,000 and $800,000 when it was offered by Sotheby's, but far exceeded this by selling to an anonymous bidder for $1.3 million.

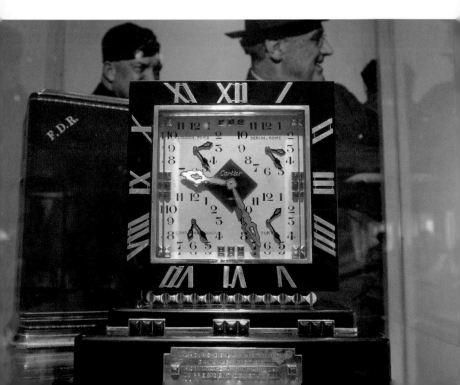

It was an exciting sale, but by no means the most expensive Cartier jewel to be sold at auction. In 2014, Sotheby's facilitated the sale of a Cartier ring set with a 25.59ct Burmese pigeon's blood ruby known as the Sunrise ruby for $30.4 million. Also that year, Christie's sold a Cartier Belle Epoque-style diamond brooch, featuring several important diamonds including a 34.8ct pear shape and 23.55ct oval shape. The jewel, which was bought as a wedding gift by King Alfonso XII of Spain for his wife in 1879, fetched $17.6 million.

Cartier watches have also been known to smash records. In 2021, a 1970s gold Cartier Crash sold for close to $885,000 at Sotheby's. This far exceeds the value of the watch itself, but the price is fuelled by rarity as Cartier only occasionally produces this quirky design, making competition on the secondary market fierce.

A verified famous owner can also drive prices up. In 2010, a Cartier Panthère diamond and onyx bracelet owned by Wallis Simpson sold for a record £4.5 million, making it the most expensive bracelet to ever sell at auction at that time.

La Peregrina is an enormous 50.56ct pear-shaped natural pearl that was cracked from an oyster in the 16th century. It was owned by a succession of Spanish kings, then European aristocracy, including the Bonapartes, before being set by Cartier into a spectacular diamond, ruby and pearl necklace in 1972 for actress Elizabeth Taylor. It sold at Christie's in 2011 for $11.8 million.

OPPOSITE: Cartier's Victory Clock, gifted to US president Franklin D Roosevelt in 1943, sold for $1.6 million at Sotheby's in 2007.

The Art
of Living

As Cartier has blossomed into a global luxury power, it has set its sights on so much more than the selling of watches and jewellery. With a build up of financial security has come the opportunity to invest in causes that are aligned with the jeweller's raison d'être.

The arts have been a keen focus for Cartier, and it supports many initiatives. But the jewel in the crown is the creation of its own art gallery in Paris. Other philanthropic activities include championing of female entrepreneurs through a dedicated initiative, supporting children in developing countries and protecting the big cat that made it famous.

OPPOSITE: A view of the Fondation Cartier art gallery in Paris at night.

Fondation Cartier

In the 1980s, artist César Baldaccini came to Cartier president Alain Dominique Perrin with an idea. It was a vision for an art gallery in Paris that would be open to all and support emerging artists, collect works and give space to multi-disciplinary forms of artistic expression.

Perrin liked the idea. He saw the opportunity to create a space that championed the arts in Cartier's name by way of corporate philanthropy. By 1984, Fondation Cartier pour l'art contemporain had opened its doors in Jout-en-Josas near Versailles. Early exhibitions included Les Années 1960, la décade triomphante, a celebration of the 1960s with works by artists including Andy Warhol, Patrick Oldenburg and Joan Mitchell.

In 1994, Fondation Cartier, as it is commonly known, moved closer to the centre of Paris, opening a new purpose-built space opposite Montparnasse Cemetery. The building itself was an artwork, created by French architect Jean Nouvel, who would go on to design many important buildings including Philharmonie de Paris and One New Change in London.

Nouvel built Fondation Cartier as an ultra-modern space of glass and steel, but this is softened by the lush gardens that surround and envelop it. The gardens are called Theatrum Botanicum and are an urban woodland filled with wildflowers.

OPPOSITE: A poster for an exhibition by photographer Malick Sidibé at Fondation Cartier in 2017–18.

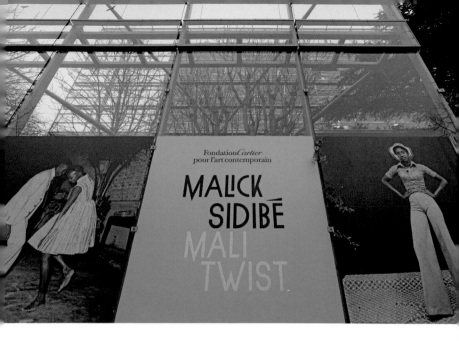

Over the years, Fondation Cartier has played host to exhibitions by established artists including Patti Smith, David Lynch, Agnès Varda and Bruce Nauman, as well as lesser-known names. It also seeks to explore a wide variety of mediums, from the photographic work of Mexican artist Graciela Iturbide to Australian sculptor Ron Mueck's enormous, hyper-realistic sculptures of people.

Since moving to Montparnasse, Fondation Cartier has run a series of evening events called Nomadic Nights. These invite performance artists to take over the venue for one night only and run immersive experiences that flow through the building and its gardens. In 2021, Damien Hirst used the gallery to show his Cherry Blossoms series of paintings that marked the artist's return to solitary painting.

Cartier Women's Initiative

In 2006, Cartier expanded its philanthropic activities with the launch of the Cartier Women's Initiative, which seeks to support female entrepreneurs who are running businesses that make a positive social or environmental impact. The mission statement of the organisation is to highlight the work of these entrepreneurs and then equip them with the "financial, social and human capital to grow their business and build their leadership skills". Since its launch, it has given out grants of $6 million to women from 62 countries.

A major element of the Cartier Women's Initiative is an awards programme. As well as bringing global visibility to the enterprises of the women who enter, there are lucrative prizes to be won. The awards are split into 10 geographical regions, with top prizes for each region of $100,000, $60,000 and $30,000. In addition, the winners will receive mentoring and training.

There are other special award categories, such as the Science & Technology Pioneer Award, as well as the Diversity, Equity & Inclusion Award, which is open to men, too. Prizes are also given to previous winners to mark continued, ongoing successes in three areas: preserving the planet, improving lives and creating opportunities for others. The women who have been recognised by the Cartier Women's Initiative spearhead a diverse range of businesses. Seynabou Dieng runs a food processing company built on inclusive partnerships with farmers in Mali. Basima Abdulrahman is a pioneer of environmentally friendly

PREVIOUS: A visitor at Fondation Cartier looks at a sculpture by artist Ron Mueck.

OPPOSITE: Lorna Rutto and Wendy Luhabe, winners of Cartier Women's Initiative Awards 2011.

construction in Iraq. Corina Huang invented medical
candy that replaces pills for those who find them difficult
to swallow. While Anna-Sophie Hartvigsen created an
educational programme on personal finances and investing
for women.

As well as providing support through financial grants and
the Fellowship programme of training and mentoring,
the Cartier Women's Initiative seeks to bring together
a community of likeminded women. Digital spaces and
physical events allow past fellows to seek each other out for
support and advice.

Philanthropy

Cartier has had a long history of charitable giving, but in 2012 it decided to formalise this with the creation of an independent charitable arm called Cartier Philanthropy. The foundation is based in Geneva, Switzerland, and while it is funded by the jeweller it operates independently to the commercial business.

Cartier Philanthropy functions by funding other non-profit organisations, with a particular focus on supporting vulnerable communities in developing countries. It does this by financing charities tackling poverty and driving long-term positive change in impoverished communities.

So far, Cartier has forged partnerships with more than 80 charities operating in 34 countries. Its total donations to date exceed CHF100 million. Some of its partners have included water charity 1001fontaines, the Asian University for Women, the Baan Dek Foundation targeting child

OPPOSITE:
Education is a key
focus for Cartier
Philanthropy.

RIGHT: Cartier
has partnered
with charity
1001fontaines
that provides safe
drinking water.

poverty in Thai slums, and Imagine Worldwide that provides educational tech to refugees.

When deciding which charities to work with, Cartier Philanthropy looks for organisations that are a fit with its four main areas of focus. These are: access to basic services, women's economic and social development, creating sustainable livelihoods and ecosystems, and funding emergency responses.

In its 2020/21 annual impact report, the foundation shared that its donations had helped more than 20,000 smallholder farmers in Mozambique to improve their farms and given more than 52,000 residents in Madagascar's Antananarivo access to clean drinking water. It also helped charities provide 50,000 families in Bangladesh with emergency humanitarian aid after the summer floods of 2020.

During the coronavirus pandemic, Cartier Philanthropy focused on funding emergency response charities,

supporting 21 non-profit organisations tackling the impact of the virus in 22 countries. In Latin America, it teamed up with Techo to mobilise 2,000 community leaders to distribute food and hygiene products to vulnerable families in Mexico, Brazil and Colombia. In the Philippines, donations to Médecins Sans Frontières helped it to provide medical assistance to 200,000 families in Marawi that were already displaced by war and living in temporary shelters.

The Lion's Share

The panther first made an appearance in Cartier's advertising in 1904 as an illustration, sitting at the feet of a Café Society woman dressed in its jewels. Since then, the majestic creature has become a regular feature of its marketing.

In 2012 came one of the panther's most spectacular roles as Cartier released a three-minute-long film titled *L'Odyssée de Cartier* to celebrate its 165th anniversary. The advertisement had taken two years to make and featured live footage of a panther, played by three animals trained by Thierry Le Portier, moving through a collage of scenes celebrating the jeweller's history.

While Le Portier might have been able to spend his earnings from the job at a Cartier boutique, the animals themselves get little more than a scratch behind the ears for their performance. In recognition of this, Cartier is a partner of conservation charity The Lion's Share that allows corporations to make a donation each time an animal appears in an advert. The money is used to protect natural habitats, create wildlife conservation areas and promote animal welfare.

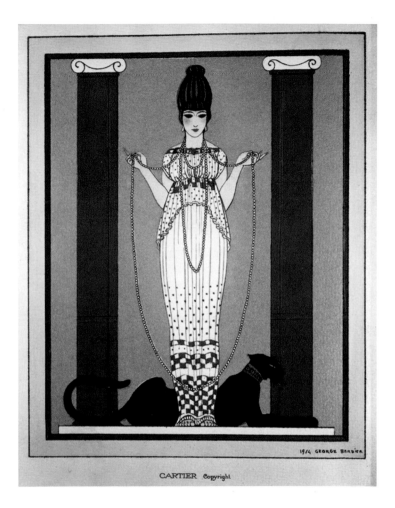

ABOVE: A 1914 Cartier advert created by illustrator George Barbier.

Continuing
the Legacy

Cartier has built an impressive
legacy. From the early days of
Louis-François Cartier making the
bold move in 19th-century Paris to
buy his master's business, through to
the pioneering work of his grandsons
Louis, Pierre and Jacques in creating a
global empire, it has come a long way.

The jeweller survived World Wars,
Revolutions and the Great Depression
by constantly adapting and seeking
out new opportunities as they came.
Through the shifts in ownership
over the years, it has evolved and
ultimately come out stronger. Now,
the challenge is how to retain its
crown as the 'king of jewellers'
through preserving the past and
preparing for the future.

ABOVE: The Cartier name is positioned proudly above its boutique in Lyon, France.

The Cartier Collection

As a rule, jewellery houses tend to make jewels for others to buy, but at an auction in Geneva in 1973, Cartier bid on one of its own pieces. The item was a Portique mystery clock, an ornate design with a dial displaying Cartier's watchmaking flourish of hands that appear to be floating. The jeweller won the bid, and the acquisition would prove to be the beginning of the Cartier Collection.

The Cartier Collection is essentially an archive of Cartier designs that the jeweller has bought back from the public domain. The collection now comprises more than 3,000 pieces, with items ranging from 1860 right through to the late 20th century.

Each piece in the Collection tells a part of the Cartier story, such as the platinum and diamond Scroll tiara made for Elisabeth Queen of the Belgians in 1910 that shows off the Garland style that won the jeweller so many royal fans. Or the bold Scarab brooch from 1924 decorated with antique ceramic wings from Ancient Egyptian times, which captures the Art Deco fervour for motifs from that period.

It has also acquired jewels crafted for some of its most famous patrons. Within the Cartier Collection are several pieces owned by Wallis Simpson, including the 1947 amethyst Drapery necklace and a Panthère brooch with the sleek beast atop a 152.35ct Kashmir sapphire. Other celebrity jewels to have been incorporated into the Collection include María Félix's 1975 crocodile necklace, heiress Barbara Hutton's 1934 string of jadeite beads, and French socialite and editor Daisy Fellowes' 1936 Hindu necklace in the Tutti Frutti style.

The Collection also comprises clocks, watches and objets
d'art made with precious materials. As well as rare, one-off
creations and commissions, archivists have sought out early
examples of some of its famous commercial collections,
including a 1969 Love bangle, a 1912 Santos-Dumont,
a 1920 Tank and a 1967 Crash.

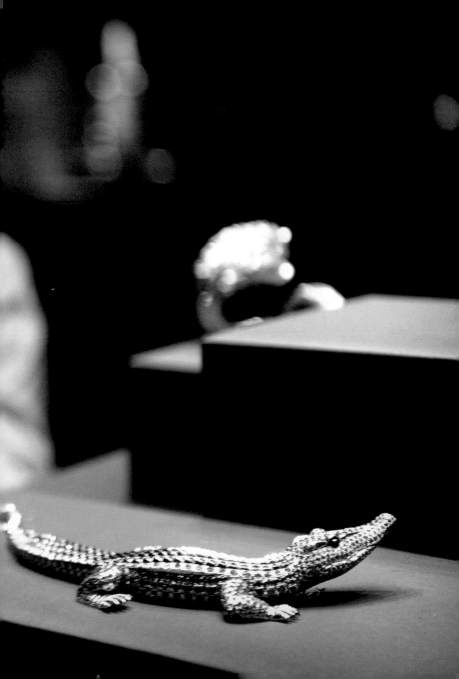

Maisons des Mêtiers d'Art

At the heart of Cartier's most special pieces are elaborate techniques that call on skills only a few people in the world possess. It would be easy for these techniques to fade out of existence if they are not passed on, and in recognition of this the jeweller has created workshops where established artisans can pass on knowledge to the next generation.

In 2002, it opened the Cartier Jewellery Institute in Paris, to provide training for working jewellers. Then in 2014, at its La Chaux-de-Fonds manufacturing headquarters in the Swiss Alps, it founded Maison des Métiers d'Art, where craftspeople practise and share the most difficult artistic crafts that underpin its jewels and watches.

Such skills include intricate metalworking. Goldsmiths are taught how to create a type of lace-like openwork called filigree, and how to master minuscule orbs of gold to create texture through a process known as granulation. Engraving – a skill that can deliver so much more than just an inscription on the back of a watch or inside a ring – is another core focus for artisans at La Chaux-de-Fonds.

Enamelling is also mastered here. There are many different types of enamel, such as the stained glass-like plique-à-jour, and cloisonné, which uses a metal framework to hold the enamel in patterns. Cartier has even developed or revived some rare styles of enamel work, including using globules of enamel in place of gold to create granulation.

Whichever method of enamelling an artisan chooses to master, all must be painstakingly perfected by hand with opportunities for error at every stage. To give an insight into

PREVIOUS: Guests look at a crocodile jewel created for actress María Félix, now part of the Cartier Collection, at the Cartier Treasures: King of Jewellers, Jewellers to Kings exhibition in Beijing in 2009.

RIGHT: The dial of this Cartier Rotonde Mystery watch, c.2014, has been decorated with a cachalong opal Bengal tiger and 500 lapis lazuli and blue agate tesserae.

how delicate the process is, an enamelled watch dial can take up to 30 hours to paint and it must then be fired in a kiln as many as 15 times to achieve the correct shades.

Another artistic skill practised at La Chaux-de-Fonds and used to decorate watch dials and jewels is marquetry. Here, tiny pieces of materials such as wood or straw are pieced together like a jigsaw to create an image. Often during the creation of a watch dial, an artisan must leverage more than 200 tiny tesserae over the course of 50 hours.

Ethical Supply Chain

Customer expectations around ethics and sustainability have changed dramatically since Cartier was first founded in 19th-century Paris. With phrases such as 'dirty gold' and 'blood diamonds' firmly part of today's mainstream dialogue, it is now important that all jewellers have answers prepared should questions around supply chains be asked.

Cartier has been a member of the Responsible Jewellery Council (RJC) since 2005 when it was founded. The RJC aims to act as a jewellery industry watchdog and offer consumers confidence in brands by having them submit to external auditing in order to receive accreditation. These audits assess factors such as responsible sourcing, human rights and safe working conditions.

In a 2021 sustainability report, Cartier claims that more than 97 percent of the gold it purchases is "responsible and traceable". It also states that 90 percent of its gold supply comes from recycled sources certified by the RJC, and that 7 percent comes from artisanal mines. Cartier has been a member of the Swiss Better Gold Association since 2013, which seeks to improve the living and working conditions of artisanal miners.

When it comes to diamonds, the jeweller claims that 95 percent of the value of its diamonds are bought from RJC-certified suppliers. It says that it is currently working on pilot schemes that will improve the clarity it can offer on the traceability and origin of the diamonds it uses.

In 2015, Cartier set up a Coloured Gemstones Working Group to try to improve the supply chain of coloured gems

in the jewellery industry. This has funded an initiative called The Gemstones and Jewellery Community Platform that provides anyone working in gems with free tools and resources that aid responsible business practices.

Cartier is also seeking to push green technology within its watch offer with its SolarBeat watch movement. As the movement is powered by the sun, watches fitted with it do not require batteries.

Cartier Today and Tomorrow

While Cartier started out as a family business in 1847 – something that defined the first century and more of its development – the jeweller and watchmaker is now part of one of the largest luxury groups in the world, Richemont. Joining it in the Richemont stable are many other leading watch and jewellery brands including Van Cleef & Arpels, Buccellati, Piaget and Jaeger-LeCoultre.

The maison continues to celebrate its history while pushing ahead. In 2021, Cartier released 150 new high-jewellery designs and launched a campaign titled The Culture of Design to showcase the enduring appeal of its most-loved designs. The Culture of Design paid tribute to its biggest watch and jewellery icons: Santos, Tank, Trinity, Love, Juste un Clou, Panthère and Ballon Bleu.

This was a powerful reminder of the design prowess and storied history of the brand, which has truly elevated its status to become one of the best-known and most-coveted jewellery and watch brands of all time.

OPPOSITE: Cartier jewellery and watches on display at a boutique in Brussels, Belgium.

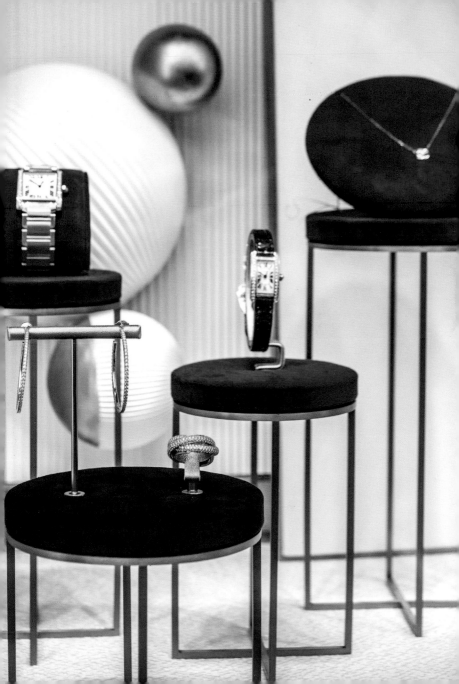

Image Credits

(t) = top, (b) = bottom, (c) = centre, (l) = left, (r) = right

Page 5 Papin Lab/Shutterstock; 7 denis kalinichenko/Shutterstock; 8 Svintage archive/Alamy Stock Photo; 10-11 adoc-photos/Corbis via Getty Images; 12(tl) GRANGER/Alamy Stock Photo, (tr) Bettmann/ Getty Images; 15 Sepia Time/Getty Images; 16-17 Arte & Immagini srl/ CORBIS/Corbis via Getty Images Vincenzo Fontana/Getty Images; 18 The Print Collector/Getty Images; 19 VCG Wilson/Corbis via Getty Images Fine Art/Getty Images; 20 Featureflash Photo Agency/ Shutterstock; 21 Sueddeutsche Zeitung Photo/Alamy Stock Photo; 22 Stephen Bartholomew/Stephen Bartholomew Photography/ Alamy Live News; 23 Jonathan Brady/PA Wire/Alamy Stock Photo; 24-25 Keystone Press/Alamy Stock Photo; 26 Guy Bell/Alamy Live News; 27 Everett Collection/Shutterstock; 28 Malcolm Park/Alamy Live News; 30 Reuters/Denis Balibouse/Alamy Stock Photo; 31(tl) K. Y. Cheng/South China Morning Post via Getty Images, (bl) Tristan Fewings/Getty Images for Sotheby's, (r) FABRICE COFFRINI/AFP via Getty Images; 33(tl) Chronicle/Alamy Stock Photo, (tr) Sipa US/ Alamy Stock Photo; 34(bl) Cyrus McCrimmon/The Denver Post via Getty Images, (br) Malcolm Park/Alamy Live News; 36-37 Sipa US/ Alamy Stock Photo; 38 Henri Cartier-Bresson/Magnum Photos; 40 Jeremy Pembrey/Alamy Stock Photo; 41 Imaginechina Limited/ Alamy Stock Photo; 42-43 HasanZaidi/Shutterstock; 44 Grzegorz Czapski/Alamy Stock Photo; 45 Paul Quezada-Neiman/Alamy Stock Photo; 46(tl) Eye-stock/Alamy Stock Photo, (tr) pidjoe/iStock, (bl) Horology/Alamy Stock Photo, (br) pidjoe/iStock; 49 American Photo Archive/Alamy Stock Photo; 51 REUTERS/Jose Manuel Ribeiro/ Alamy Stock Photo; 52-53 REUTERS/Denis Balibouse/Alamy Stock

PREVIOUS: A Cartier employee sweeps the pavement outside its Paris store in 2015, ready to open for a new day.

Photo; 54-55 PA Images/Alamy Stock Photo, 57 PA Images/Alamy Stock Photo; 58-59 REUTERS/Denis Balibouse/Alamy Stock Photo; 60 Imaginechina Limited/Alamy Stock Photo; 61 Pool BENAINOUS/ EDELHAJT/Gamma-Rapho via Getty Images; 63 Patti McConville/ Alamy Stock Photo; 64 Pascal Le Segretain/Getty Images for Cartier; 65 Pascal Le Segretain/Getty Images for Cartier; 66-67 REUTERS/ Mike Segar/Alamy Stock Photo; 69 Ron Galella/Ron Galella Collection via Getty Images; 70 Bettmann/Getty Images; 71 Bettmann/Getty Images; 72-73 Paul Slade/Paris Match via Getty Images; 75 Historic Images/Alamy Stock Photo; 76-77 FRANCOIS GUILLOT/AFP via Getty Images; 79 ScreenProd/Photononstop/Alamy Stock Photo; 80 Pictorial Press Ltd/Alamy Stock Photo; 81 ScreenProd/Photononstop/ Alamy Stock Photo; 83 GL Archive/Alamy Stock Photo; 84 REUTERS/ Denis Balibouse/Alamy Stock Photo; 85 PA Images/Alamy Stock Photo; 86(t) REUTERS/Suzanne Plunkett/Alamy Stock Photo, (bl) PA Images/Alamy Stock Photo, (br) PA Images/Alamy Stock Photo; 87 PA Images/Alamy Stock Photo; 89(tl) Elizabeth Goodenough/ Everett Collection/Alamy Live News, (tr) Allstar Picture Library Ltd/ Alamy Stock Photo, (b) Everett Collection/Shutterstock; 90 WENN Rights Ltd/Alamy Stock Photo; 91(t) Everett Collection Inc/Alamy Stock Photo, (b) Photo 12/Alamy Stock Photo; 92-93 Mike Coppola/ Getty Images for People.com; 94-95 Papin Lab/Shutterstock; 96 andersphoto/Shutterstock; 98 Imaginechina Limited/Alamy Stock Photo; 99 WENN Rights Ltd/Alamy Stock Photo; 100 HasanZaidi/ Shutterstock; 101 Jeanne Frank/Bloomberg via Getty Images; 102 andersphoto/Shutterstock; 103 dpa picture alliance/Alamy Stock

OPPOSITE: A Cartier necklace with a carved gemstone, one of the maison's specialities.

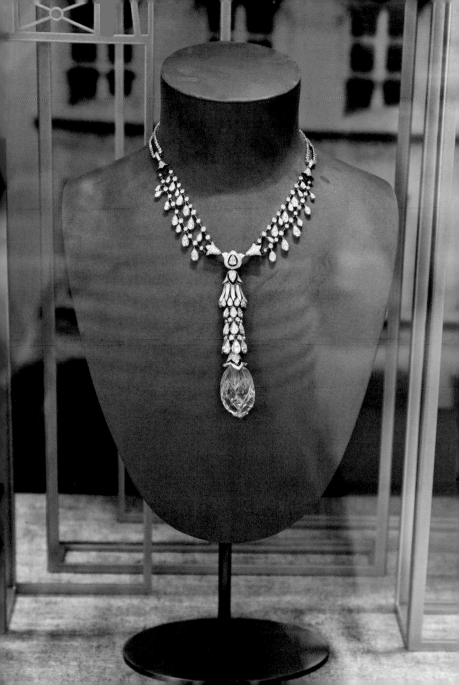